ENGLISH CONVERSATION PICTURES

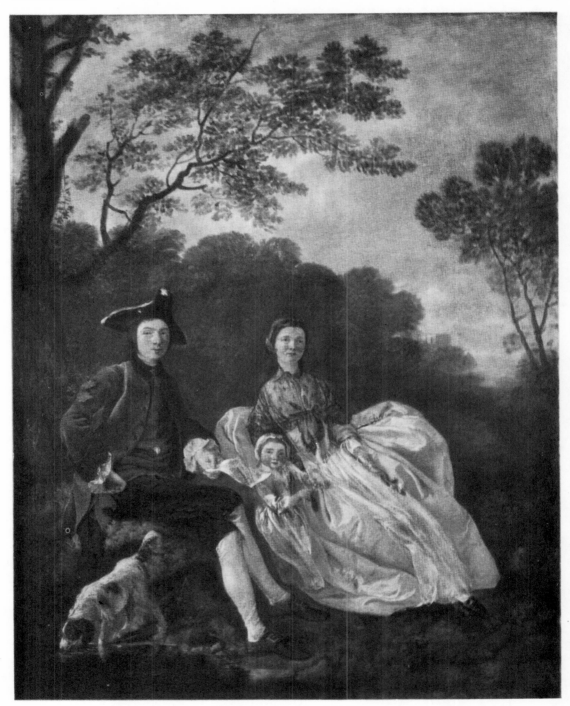

THE ARTIST, HIS WIFE, AND CHILD

Thomas Gainsborough *Collection of the Right Hon. Sir Philip Sassoon, Bart.*

ENGLISH CONVERSATION PICTURES

of the

EIGHTEENTH AND EARLY NINETEENTH CENTURIES

With an Introduction and Notes by

DR. G. C. WILLIAMSON

HACKER ART BOOKS
NEW YORK, N.Y. 1975

First published London, 1931
Reissued 1975 by
Hacker Art Books
New York.
Library of Congress Catalogue Number 74-78420
ISBN 0-87817-157-6
Printed in the United States of America

PUBLISHERS' NOTE

THE PUBLISHERS must express their thanks to the owners of the pictures illustrated for the granting of numerous facilities, and for the courtesy shown in sanctioning their reproduction in this volume. The task of selection and reproduction was, of course, made lighter by the assembling of so many of these pictures at the Exhibition organised by Mrs. Gubbay and Sir Philip Sassoon in aid of the Royal Northern Hospital, and held at 25 Park Lane in the Spring of 1930. It was originally intended to publish a complete catalogue *de luxe* of this Exhibition, in a more extensive form than that now adopted, with a very much fuller letterpress and detailed notes on the colours of the pictures. The exigencies of cost, however, and the generally unfavourable conditions of the moment have prevented the fulfilment of this intention; but it is hoped that the present more concise work will be found a not altogether inadequate review of its subject.

A further acknowledgment must be made to the Proprietors of The Amalgamated Press Ltd., *The Illustrated London News*, *The Collector*, *The Sketch*, and *The Connoisseur*, who have kindly placed colour blocks originally made for their journals at the publishers' disposal; also to Messrs. Spink & Son, Messrs. Arthur Tooth & Sons, Messrs. A. Ackermann & Son Ltd., the Proprietors of *Country Life*, "Artists Illustrated" Ltd., and Messrs. Gowans & Gray of Glasgow for the loan of photographs. Reproductions have also been made from photographs by Messrs. A. C. Cooper, H. Morgan (the Kingham Studios), W. F. Mansell, T. E. J. Stephenson, J. E. Birtles (the Leigh House Studios), Henry Dixon & Sons, Emery Walker Ltd., William E. Gray and R. L. Warham.

FOREWORD

By The Right Hon. Sir Philip Sassoon, Bart.

IT is a compliment which I much appreciate to be asked to write a Foreword to this book. I am deeply interested in English Conversation Pictures, and it is a source of real pleasure to me to know that this fine volume, which Dr. Williamson has compiled with so much care, knowledge and feeling, will prove a means of bringing many others to share my enthusiasm for this fascinating branch of English art.

That our present knowledge of the life, habits and outlook of eighteenth-century England is due in no small degree to the profusion of literary records that remain to us, no one, I think, will deny; but I feel at the same time that our real sense of intimacy with the period is also due in large measure to our familiarity with the intriguing little pictures of men, women and events, left us in the form of Conversation Pieces by a succession of brilliant painters. An annotation of these pictures, compiled with the accuracy and understanding that mark the pages of this book, constitutes an invaluable introduction to the social and domestic life of the times at which they were painted.

Looking through the illustrations, one can only regret that this type of painting had not an earlier birth and a longer period of popularity; that it could not have illuminated more distant and obscure phases of our social development, and have flourished in a continuous tradition to our own day. But at the same time we must perhaps sadly concede that it was a creature of the times it portrayed—a product of a manner of life more spacious and comfortable than that which preceded it, less hurried and strenuous than that which followed it. While the detail and history of each individual picture are a mine of information to the student of social conditions, the emergence and growth in popularity of the form itself help to characterise an age.

Absorbing as these Conversation Pictures are as a record of one of the most interesting periods of our history, few who have occasion to study them are likely to neglect that they are most of them, at the same time, remarkable achievements as paintings. The carefully chosen and comprehensive list illustrated in this volume includes work not only by men who made this particular form their chief method of expression, but also by some of the greatest painters of the English school. The finest examples possess an æsthetic appeal that it is impossible to resist.

The Conversation Picture does in fact present, as is strikingly illustrated in this book, scope for the most glittering talent and for a wide diversity of treatment. And if English social conditions at the close of the seventeenth century provided ample

justification for its inception and rise in popularity, I find it difficult to assign a valid reason for the complete disappearance of this form some hundred and twenty years later. It is still more difficult to understand why, in these days of flats and smaller houses, it should not regain some measure at least of its old vogue. There is no other type of painting which unites in greater degree the advantages of convenient size and decorative charm with the abiding interest of portraiture.

I hope that this book will meet with the success which its undoubted merit deserves, and that it will serve not only to increase public interest in one of the most fascinating branches of our art, but also to stimulate some of our present-day painters to adapt to modern methods a form which seems to fulfil in so many ways the requirements of our own times.

PHILIP SASSOON

CONTENTS

INTRODUCTION

THE term "conversation piece" has been coined to classify a particular type of picture popular in England during the eighteenth and early nineteenth centuries. Sir Philip Sassoon has defined the essential quality of one of these pictures as a representation of two or more persons in a state of dramatic or psychological relation to each other; and this statement may be said to apply to most of the examples illustrated in this book. It is noteworthy that the groups are nearly always depicted in surroundings familiar to the sitters, either indoors or in the open air, in the library of the country house in which they live, or in some favourite part of its grounds, with a familiar view of landscape or river in the back ground. The actual portraits are nearly always those of members of the same family or of their intimate friends; and there is a tendency to represent each figure in some manner that indicates the tastes or personality of the sitter. Thus in *Plate LVI* the *motif* of the picture is angling; in *Plate LXVII* (*below*), billiards; while in *Plate XLIII* Charles Towneley is naturally enough shown among his marbles. Again, a large number of groups show two or more persons playing on musical instruments, not so surprising in an age when practically every person of quality was able to put up some sort of a performance on at least one. Many equestrian groups set forth the English passion for horses at this period; but above all other themes (and not surprisingly in so prolific an age) that of parenthood takes supremacy. There is the young couple with their newly-born child, as in *Plate LXVI* (*below*); the couple of maturer years surrounded by a sturdy family, as in *Plate LIX*; or the patriarch with three generations of his family about him, like old Mr. Drummond in *Plate XLVI*.

It must be remembered that at the period when most of these pictures were painted artists were in the habit of moving about the country from one large house to another, and of staying at each for a while to paint portraits or groups. John Russell's Diary is full of allusions to his visits to country houses, chiefly in Yorkshire, when he would often paint portraits of. every member of a family; and I am inclined to think that in most cases the poses adopted for representation were decided by the artist, and not, as has been suggested, by the head of the family. It seems to me that the artist would be attracted by certain domestic scenes typical of the household, and would decide there and then on depicting the family in one of them. I cannot conceive, for instance, that Lord Willoughby de Broke and his family especially arranged themselves at the breakfast table in the attitudes in which Zoffany has shown them (*Plate XXXIX*). It was surely by a fortuitous accident that the trained eye of the painter recognised the charm of the scene, and decided there and then to put the group on canvas just as it first appeared to him, thus achieving a painting almost unparalleled in its interest of purely domestic life in a great house in the eighteenth century.

Life, indeed, at that period was more gracious and unhurried than it is at the present day. As we see it in these paintings of the later eighteenth century, it was touched with qualities of stately dignity and decorous orderliness that are noticeably lacking in the times in which we live. These glimpses into the quiet country life of our ancestors are refreshing, if nothing more, to a generation like our own, not born to leisure.

The conversation piece is of added value as a record of the changing phases of costume throughout the period in which it flourished. The paintings of Devis and Zoffany allow us to appreciate the real beauty of the flowing satin dresses worn by the ladies of their time, the voluminous folds of which add as much to the effect of their pictures as does the representation of the texture of the material give proof of the painter's technique. Such details as the beautiful

lace caps worn by old ladies (as, for instance, by old Mrs. Dutton in *Plate XL*), the sober attire of clergymen (*Plate LXVII*), the university dress of an undergraduate (*Plate XXXVIII*), the rich gold trimmed waistcoats with their ornamental pockets worn by men of fashion (*Plates XXXVI, XXXVII* and *XLIII*) and the towering piles into which ladies dressed their powdered hair (even for a river party, as in *Plate LII*) are of extraordinary interest to-day. Indeed, for the student of costume there is hardly a plate in this book that does not contain some revelation, large or small, in the details of dress throughout the period.

Then, again, we get fascinating glimpses of typical rooms from the early years of the eighteenth century up to the eighteen-thirties, when Leslie shows us Lady Holland looking at us from behind her fan in the library of Holland House (*Plate LXXXIV*). Generally the room is plain and simply panelled, never overcrowded with furniture, the few paintings on the walls, the colouring of an Eastern rug, the fine bronzes or oriental porcelain on the shelf of the beautifully carved chimney-piece, adding those touches of interest that invest it with personality. Here, again, the student may find endless pleasure in the details of decoration and furnishing—in the carved jambs of a chimney-piece, the dainty silver and porcelain of a tea-service, the mellow colour of hangings, or the beautifully bevelled mirror with its quiet landscape reflection through a window. We can almost hear the tinkling notes of the harpsichord and watch the graceful steps of the minuet and pavane, see the Eastern bird fluttering in its curious cage and the children in their long dresses at play with their few and comparatively precious toys.

Of course in some of the pictures, such, for example, as that belonging to the Duke of Atholl (*Plate LVI*), the composition is not strictly true. We know that the landscape background was painted in Scotland, and that the family was grouped together at different times in London so that Zoffany might introduce all the necessary figures; and we can be fairly certain that all of those shown in the finished picture were never together by the banks of that river at one particular moment, engaged in the manner in which we see them in the painting. There *were*, however, such family parties, and there *were* parties under the trees in India, when members of a family were waited upon by native servants, as in the Impey and Auriol groups shown on *Plates LIV* and *LV*. Doubtless there were also gatherings out-of-doors such as we see in the Drummond family group, for instance (*Plate XLVI*), the old man seated under a tree, the children on their ponies, the servants hovering in the background. The artist would be delighted with the grouping and make hurried sketches to perpetuate each pose; while if some child were absent, he would add in a likeness, so that what had begun merely as a group would end as a complete family portrait.

In an account of the exhibition of conversation pieces held in 1930, a writer referred to it as a peep-show, or rather as a series of peep-shows. I think that this comparison is a very apt one. In the days when I was a child a peep-show that amused me, as it had amused two previous generations, bore the name of a *Polyorama*. Its pictures could be viewed in two different ways —with the upper part of the apparatus open, so that you saw the picture as it appeared with the top light falling upon it, and with the same upper portion closed and the back flap open, so that one looked right through the picture, and certain orifices in it that were covered over with different coloured gelatine appeared. A house viewed by the first method would simply appear as an ordinary house; by the second, one had the illusion that it was on fire. You would see Temple Bar first by daylight, and then lit up with numerous small lamps for the Coronation of George IV. A great fountain, viewed by the second method, would appear illuminated and in motion.

Memories of this ingenious device came to me when I was studying the pictures illustrated in this volume, because more than one has, as it were, a story behind a story. The boy drawing at the table beside his father in the picture on *Plate LXVI* (*above*) makes an interesting and charming composition; when one looks closer, however, one notices that he is using Indian ink, and learns that the importation of this commodity from China was the special business of

the father, who is seated beside him. This fact lends an absolutely new interest to the picture. Again, in the group on *Plate XLIX*, a glance will show that the musician is holding his flute wrongly; and one learns that this man played the instrument so badly, and was so insistent not only that he should be represented with it, but as playing it through the sitting, that Zoffany insisted on his relinquishing it while the picture was being painted, and added it in later, by a curious slip, in an inaccurate position.

Lord O'Hagan's picture on *Plate XLII* has also its "story within a story." Charles Towneley, who appears in this group with several friends, had undertaken to present his portrait to the Society of Dilettanti, of which he was a member, and had also nominated for membership the five friends with whom he is shown. Not one of these five, however, was successful in gaining admission to the coveted circle, and Towneley, in a fit of pique, refused to present the portrait, preferring to pay year after year the fine that was demanded in lieu of presentation. In the next picture (*Plate XLIII*) we see him again, in the library of his house which is still standing, surrounded by the marbles which it had been his life work to collect, and which seem somewhat to overcrowd a smallish room. As a matter of fact, the room is even smaller than it appears to be, and the marbles were brought into it from other parts of the house so that their owner and his three friends might be painted surrounded by them.

In the Hervey group on *Plate XLV* we see all the figures grouped around Captain Hervey, and in the distance a view of the sea, with a warship upon it. He has just been appointed to the command of this ship, and is in the act of taking leave of the members of his family. His father commissioned this picture to commemorate the important event. Look at Aunt Peggy in the Nugent group (*Plate XLIV, below*), and remember all the pleasant stories that are told about her, and her goodness to the children. Look at the Dutton family at cards (*Plate XL*), and remember that the old lady was disturbed while reading a book of devotion by her husband's enquiry as to a suitable card to play. If we examine her expression and that of her daughter, it is clear that some actual occurrence is in progress, and that the picture is more than a mere group of posed figures. Look at Horace Walpole in the Devis picture on *Plate XXXI*, rather stiffly presenting Kitty Clive with a sprig of honeysuckle; recall the meeting between these two notable persons, and think how his attitude contrasts with the malicious elegance of his correspondence. Look at the picture on *Plate XXVIII* of the lady and gentleman who were attracted to one another at the masked ball at Ranelagh, and unmasked in a quiet spot only to find that they were husband and wife.

We have already mentioned the popularity of music amongst educated people in the days of Zoffany; turn then to his picture of the Sharp family (*Plate LII*), or, for an earlier example, to the musical gathering at Wanstead House depicted on *Plate XXII*. Remember that in the group of the Young family (*Plate LIII*) two god-parents of the children demanded from the artist the separate portraits of their respective *protégées*, hence bringing into existence three distinct pictures which are all replicas of figures from this interesting painting. Look at old Andrew Drummond sitting under a tree (*Plate XLVI*), and note the famous gold-headed cane which he used on his long walk from Edinburgh to London as a young man. So one might go on indefinitely, watching Dr. Johnson at tea with the Garricks (*Plate LVII*), seeing the same family in their garden, grouped on the steps of Shakespeare's Temple (*Plate LVIII*), and then again Garrick on the stage in some of his most famous parts (*Plates LXII, LXIII,* and *LXIV*). All these pictures are important and interesting viewed simply as pictures; viewed as peep-shows, little tags of family history and anecdote come to life and render them infinitely charming.

Sometimes they have mysteries attached to them, and in Zoffany's group of his own family (*Plate LI*) there is one more child than was actually living at the time the picture was painted. Again, we may ask whether the green and white striped material which appears in three of Zoffany's groups was a particularly popular one at the period, or whether it was simply that used in the painter's studio (*Plate LVII*).

3

Hogarth's pictures afford a different kind of peep-show, one that admits a measure of the coarseness and brutality of his age; for Hogarth was uncompromisingly a realist. At the same time he delighted in domestic scenes, some of which are of extraordinary charm, particularly when children are introduced, as in the picture on *Plate XVIII*, when a group of them are performing a scene from Dryden's play, "The Indian Emperor", for the amusement of a distinguished company. Another painter of this earlier period, Laroon, has also left us a delightful and interesting group in "The Duke of Buckingham's Levée", illustrated on *Plate V*, while mention must be made of the deliciously witty picture by Thomas Patch on *Plate XXI*, where the artist has depicted a group of English *cognoscenti* in Florence practically in caricature.

Sometimes the scope of these pictures is extended beyond the purely domestic, and they become records of some particular historic event, as in Hogarth's "March of the Guards to Finchley" (*Plate XIX*), which shows the regiment's disorderly advance through the London suburbs on the northward march to quell the second Jacobite rising. More often, however, the setting is peacefully domestic. Whether we are with Hogarth at a wedding, with Highmore in the Green Room of Drury Lane, out hunting with Marshall, enjoying the leisured, urbane life of country houses with Devis or Zoffany, or out in the open with Gainsborough, in a garden or in the Suffolk countryside which he used as a background to three splendid groups illustrated in this book, we know that not only are we receiving truthful representations of the life of a past age, but representations entirely in harmony with its spirit and genius; and in enjoying these records of past manners, customs and habits, we are for a moment transported away from the bustle, hurry and fret of the twentieth century to the brink of an existence which, if it lacked many of the boasted improvements of modern civilisation, was at any rate more seemly, decorous and dignified than our own.

A final word must be said on the choice of the illustrations to this volume. In scope they cover the period from the early years of the eighteenth century to the accession of Queen Victoria, a matter of about 120 years. An attempt has been made to illustrate typical work of the widest possible range of painters, and at the same time to show the very broad range of subjects to be admitted under the category of "conversation pieces." The main body of the plates, however, represent those delightful domestic scenes, indoor and outdoor, that the term generally implies. Practically all the pictures reproduced are from private collections, but the task of selection was made lighter by the assembling of so many splendid examples at the Exhibition organised by Mrs. Gubbay and Sir Philip Sassoon, and held in the spring of 1930.

Most of these pictures have been seldom, if ever, reproduced previously, and are thus little known to the public. For this reason it has been considered appropriate to append a series of notes on each example illustrated, which will be found in the pages following this introduction, with brief biographies of each of the twenty-one painters represented. To enumerate or attempt to catalogue the full quota of "conversation pieces" executed over the period would, of course, be an impossible task. They are scattered over the country houses of England, large and small, and at this time of social flux the sale-rooms are continually bringing to light new treasures. It is hoped, however, that the publication of this representative selection will prove a useful introduction to the study of these delightful productions, and add something to the student's knowledge of one of the finest and most lovable of the phases of English pictorial art.

NOTES ON ARTISTS
AND PICTURES

JAMES SEYMOUR

This painter of hunting subjects was born in London in 1702, the only son of a banker—a great lover of art who drew well himself, and was an intimate friend of Sir Peter Lely and other painters of the time. The son excelled in sketching horses, though his colouring was often weak and inadequate. Comparatively few of his works are known, though one or two were engraved. He died in London in 1752.

PLATE II. FAMOUS HUNTERS BELONGING TO HIS ROYAL HIGHNESS THE DUKE OF YORK. In the collection of HIS ROYAL HIGHNESS THE DUKE OF YORK. *Size of original:* 32 by 56 inches.

Three splendid horses are depicted, a black hunter being led out of its stall, and a light and a dark chestnut tethered in their stalls adjoining. Two dogs are following the black hunter. The anatomy of the animals is very exactly represented, but the effect of this clean, precise technique is exceedingly pleasing.

PLATE III (*above*). SIR ROBERT FAGGE AND THE GIPSY. In the collection of THE LORD HYLTON. *Size of original:* 24 by 36 inches.

Despite the *naïveté* of the treatment, there is a pleasing freshness about this little picture which must be considered primarily as a study of a horse, rendered with considerable precision.

JOHN WOOTTON

Wootton was eminent at his time as a landscape and animal painter. He is believed to have been born in about 1668, though the date is uncertain, and he died suddenly in 1765. He studied under Jan Wijck, and settled for a time at Newmarket, where he painted racehorses and their owners, a type of work in which he excelled. He also painted some landscapes in the style of Claude Lorrain and Gaspard Poussin, and was responsible for the illustrations to the first edition of Gay's "Fables", published in 1727.

His sporting pictures can be seen in many English country houses.

PLATE III (*below*). MRS. J. WARDE (*née* BRISTOW) ON A WHITE HORSE. In the collection of CAPTAIN J. R. O'BRIEN WARDE. *Size of original:* 46 by 54 inches.

The lady is mounted on a white horse, and is shown in the act of leaving the stables for her ride. Behind her stands the groom, bringing out a black horse, which he is about to mount. Near by are two dogs, one a greyhound.

JOHN MARCELLUS LAROON

Strangely overlooked, with his work frequently attributed to other artists, John Marcellus Laroon has for many years deserved more attention than he has obtained. There were two Laroons; one, known as "Old Laroon", was born at the Hague in 1653, and taught by his father, who is also said to have been a painter. Later, he came over to London, but subsequently lived mostly in Yorkshire, where he was employed by Sir Godfrey Kneller to paint draperies, at which occupation he was considered particularly to excel. He was also an engraver, but we know nothing of any particular pictures painted by him.

His son, John Marcellus, known as "Young Laroon", is declared to have been a friend of Hogarth, and to have had some influence upon that artist in his later days. He was born in London in 1679, and died there in 1772. His life was one of many vicissitudes. For a while, he was a diplomatist; then he became an actor, and played and sang at Drury Lane Theatre. Later he determined to be a solicitor, and in 1707 obtained a commission in the army in the Foot Guards, serving with some distinction in several foreign campaigns. He returned to England in 1712, and was raised to the rank of Captain in 1732. Retiring from the army in 1734, he devoted the remainder of his life to painting, and died in 1772.

PLATE IV. A Lady and a Gentleman Walking in a Park. In the collection of Dr. Tancred Borenius. *Size of original:* 24½ by 20¼ inches.

This picture is surprisingly bold and direct in treatment and colouring. The man is in black with a red collar, and the lady wears a dress of rich, pink brocade.

PLATE V. The Duke of Buckingham's Levée. In the collection of Samuel Howard Whitbread, Esq. *Size of original:* 37 by 30 inches.

A delightful group, very much after the manner of Hogarth. It is assembled in the notable room in the Duke of Buckingham's house, the walls of which are almost entirely covered with pictures. The figures are elegantly and even exotically clad, and the whole picture glows with rich colour.

JOSEPH HIGHMORE

This artist, the son of a coal merchant, was born in 1692. At first articled to an attorney, he later set up a studio in Lincoln's Inn Fields. He was employed to make some drawings by Pine for his prints of the Knights of the Bath on the revival of that Order in 1725, an occupation that brought him into touch with several of the Knights, whose portraits he painted. As a result, George I commissioned him to paint a portrait of the Duke of Cumberland, which was very popular, and was engraved in mezzotint by Smith. Highmore went abroad in 1723 in order to study the works of Rubens, for which he had a great admiration, and spent most of his time at Antwerp. On his return, he executed a delightful series of twelve pictures illustrating Richardson's "Pamela". This group came into the market in the middle part of the nineteenth century, with the result that the paintings are divided between the National Gallery, London, the Fitzwilliam at Cambridge, and the National Gallery of Melbourne, Victoria. Highmore was also a clever writer, and the author of several books. He retired in 1761 with a substantial fortune, and died at Canterbury in 1780. Several of his portraits are in the National Portrait Gallery, London.

PLATE VI. The Green Room, Drury Lane. In the collection of The Lord Glenconner. *Size of original:* 26 by 31 inches.

This picture was at one time attributed to Hogarth, but a comparison of its technique with that of other well-known pictures by Highmore has proved that it must have been that painter's work. It represents Barry rehearsing the part of Romeo before Miss Pritchard, Mr. Pritchard, Fielding, Quin and Lavinia Fenton.

PLATE VII. A Family Group. In the collection of The Earl of Plymouth. *Size of original:* 25½ by 30½ inches.

It is not known who are represented in this delightfully direct painting, which is one of Highmore's best groups.

WILLIAM HOGARTH

Hogarth was born in London in 1697, it is believed at Bartholomew Close. He died at Chiswick in 1764, and is buried in Chiswick Churchyard. In his early days he was apprenticed to a silver plate engraver in Cranbourne Street, and there is an example of his engraved work on a precious metal still in existence, presented by him to one of his early patrons. Later on he took to designing plates for booksellers. The work of his maturity as a portrait and subject painter may be said to have inaugurated one of the most important and persistent streams of influence in English pictorial art, one that is still apparent at the present day.

PLATE VIII (left). THE GRAHAM FAMILY. In the collection of THE EARL OF NORMANTON. *Size of original:* 64 by 71 inches.

This picture is believed to represent the children of Robert Bontine Cunningham Graham of Gartmore. It belonged up to 1814 to Mr. R. R. Graham of Chelsea, then passed to Mr. William Seguier, the first Keeper of the National Gallery, was by him sold to Mr. G. Watson Taylor, from whose collection it was purchased by the Earl of Normanton for £94 10s.

References in writings: Austin Dobson's "Hogarth", p. 212.

PLATE VIII (right). LORD GREY AND LADY MARY GREY AS CHILDREN. In the collection of LEONARD GOW, Esq. *Size of original:* 41 by 35 inches.

This, with the picture shown on the same plate, is probably one of the most charming child studies known in English painting.

PLATE IX. THE STAYMAKER. In the collection of SIR EDMUND DAVIS. *Size of original:* 28 by 36 inches.

The scene is in the apartment of the staymaker, who is fitting on a corset to a lady, while an attendant holds up a mirror. In the centre of the picture is a boy, probably her son, who holds a whip in his hand and steps towards his mother, watching the proceedings with great interest.

In the distance, seated on a settee, are two women, one nursing a baby, probably put into their care by the mother while her corset is being fitted. There is another child on the right of the picture.

The picture originally belonged to S. Ireland, and in 1833 to Mr. W. B. Tiffin of the Strand. It then came into the possession of Mr. Fairfax Murray, who bought it at the Foreman sale in June, 1899, and from his sale it was acquired by its present owner.

It was etched by Joseph Haynes in 1782, and the first state is the proof before the writing.

References in writings: Austin Dobson's "Hogarth", pp. 221, 267.

PLATE X. A FAMILY PARTY. In the collection of SIR HERBERT COOK, BART. *Size of original:* 21 by 29½ inches.

On the extreme left of the picture a man and a lady are seated at a table playing a game, and at the foot of the table is a partially overturned work-basket, towards which a kitten is rapidly making its way. At another table, drinking tea, are a man and a woman. Between them and the first couple another man stands under a chandelier. On the extreme right of the picture is a younger man, seated, playing with a dog. There is a handsome mantelpiece in the room, over which is a bust, and, in lieu of a fire, a large ornamental vase stands in the opening. There is a window on the right with draped curtains.

PLATE XI. THE BROKEN FAN. In the collection of THE LORD NORTHBROOK. *Size of original:* 26 by 27 inches.

The ladies in this picture are said to be Lady Thornhill, Hogarth's wife (who was formerly Miss Thornhill) and Hogarth's sister. One lady is in black with a white cap, resembling that of a widow, and is probably Lady Thornhill. Another holds a fan in her hand, while the third is seated at a round table, either writing or sketching. There are two dogs near by, playing with a broken fan.

References in writings: Austin Dobson's "Hogarth", pp. 10, 36, 146 and 277.

PLATE XII. THE LADY'S LAST STAKE. In the collection of THE DUKE OF RICHMOND AND GORDON. *Size of original:* 35½ by 41 inches.

There are two versions of this picture, which has not always born the same title, having been previously known as "Picquet", and also as "Virtue in Danger". Hogarth appears to have painted it twice. The first picture was bought by Lord Charlemont, who paid £100 for it, and was greatly delighted with his acquisition. There are some letters relating to the subject printed by John Ireland, and others are alluded to in the Charlemont papers in the Twelfth Report on Historical MSS., 1891.

The lady is reputed to be Miss Hester Lynch Salusbury, better known as Mrs. Thrale or Mrs. Piozzi, but this has never been satisfactorily verified. Mrs. Piozzi's own account of the

circumstances is in a letter to Sir James Fellowes, written October 30th, 1815, when she was seventy-four, but it is full of inconsistencies. In this she states that she was fourteen at the time, though she was more probably eighteen. She adds that Hogarth promised her the picture, but it is pretty clear that he was painting it on commission; and she told an entirely different story to the correspondent of the *Gentleman's Magazine*, to whom she stated that Hogarth had merely made a sketch of her one evening in her uncle's house.

Lord Charlemont's picture was exhibited in 1814, and was sold at Christie's in 1874 for £1,585 10s. It then passed into the possession of Mr. Louis Huth, and now belongs to Mr. Pierpont Morgan. There is not the slightest reason to doubt its authenticity, or that of the Duke of Richmond's picture, which has every possible evidence of being by Hogarth; and it is quite a possible thing that both of Mrs. Piozzi's stories may be accurate, and that the Duke of Richmond's picture is the one that was drawn in her own uncle's house, from which, perhaps, the picture that is now in America was painted. It was engraved by Cheesman, and published May 8th, 1825, by Hurst, Robinson and Co. There is a proof of it before letters in the British Museum.

References in writings: Austin Dobson's "Hogarth", pp. 124, 127, 142, 205, 282.

PLATE XIII. THE CHOLMONDELEY FAMILY. In the collection of THE MARQUESS OF CHOLMONDELEY.

The group is depicted in a library, and the details of the background are full of interest to the student of the period. The head of the family is seated in the centre of the picture, with a relative or attendant standing by his chair, and his wife sitting beside him, holding her baby on the edge of a table. Two pretty little boys are playing in the entrance to an alcove, which is seen to be entirely hung with pictures. As a foil, in the opposite corner of the canvas, two Rubens-like *putti* are holding back a heavy curtain-drapery. The picture is signed and dated 1732, but appears to have been unknown to Dobson when he wrote his book on Hogarth, as no mention is made of it.

PLATE XIV. THE WEDDING OF MR. STEPHEN BECKINGHAM AND MISS MARY COX OF KIDDERMINSTER. In the collection of JAMES CARSTAIRS, Esq. *Size of original:* 50 by 40¾ inches.

It is suggested that this wedding took place at St. Benet's, Paul's Wharf, where Fielding married his second wife, but there is no doubt that the church is St. Martin's-in-the-Fields, though either the east end has been altered or the artist has not produced an exact representation of its architecture. In any case, the rendering of the background brings out Hogarth's full talent for painting architectural detail. The wedding group occupies the entire foreground of the picture, while two spectators, a man and a boy, watch the proceedings from a gallery above. The appearance of two *putti* holding a cornucopia above the bride is a charming touch, which at the same time concentrates attention on the central figures of the group.

Former Exhibitions: In 1894, by Mrs. Herbert Deedes, and at Whitechapel, in the "Georgian England" Exhibition, 1906, by Mr. William Deedes. *References in writings:* Austin Dobson's "Hogarth", p. 197.

PLATE XV. Study for THE MASKED BALL AT THE WANSTEAD ASSEMBLY. In the collection of THE BOROUGH OF CAMBERWELL, SOUTH LONDON ART GALLERY. *Size of original:* 27 by 35½ inches.

A brilliantly executed study, full of life and movement. A party is shown dancing by candle-light in the Wanstead Assembly Rooms. It has been stated that the figures include sketches of Earl Tilney, Lady Tilney and their cousins. The picture is believed to have been painted for Lord Castlemaine between 1714 and 1722. It formerly belonged to Mr. W. Long Wellesley.

Former Exhibitions: In 1875, by Mr. William Carpenter, of Forest Hill. *References in writings:* Austin Dobson's "Hogarth", pp. 113, 196.

PLATE XVI. THE LAUGHING AUDIENCE. In the collection of L. C. LEWIS, Esq. *Size of original:* 22½ by 17½ inches.

This picture was originally called "A Pleased Audience at a Play". It was painted in 1730, and is known to have been exhibited in 1814 by R. B. Sheridan, in whose possession it then was. It

subsequently passed into the well-known collection of Mr. George Watson Taylor, and at his sale in 1832 fetched £21. It was sold again in 1848, at Mr. Richard Sanderson's sale, and then fetched £51 9s. There is said to be in existence an original oil sketch, 16 by 19½ inches, depicting the Beau and the Orange Girl who are shown in the top left-hand corner of this picture.

References in writings: Austin Dobson's "Hogarth", pp. 41, 200, 239.

PLATE XVII. Scene from "The Beggar's Opera", by John Gay. In the collection of The Duke of Leeds. *Size of original:* 24 by 29 inches.

The scene is from the third act, and represents Macheath in prison, with Lucy and Polly on either side of him pleading on their knees to the turnkey and another official. On the extreme right and left are boxes placed actually upon the stage, which, it seems, were reserved for distinguished members of the audience, some of whom are seen seated in them.

The picture was painted in 1728-1729, and acquired by the fourth Duke of Leeds, at Rich's sale in 1762, for £35 14s. It was engraved, from the original painting, by William Blake, and published by Boydell's, July 1st, 1790. There are four states of the print. There is also believed to be an original pen and ink study for it in existence, and there is a sketch for it in chalk on blue paper in the Royal Collection.

References in writings: Austin Dobson's "Hogarth", pp. 22, 196, 272.

PLATE XVIII. Scene from the Indian Emperor. In the collection of Mary, Countess of Ilchester. *Size of original:* 50 by 56 inches.

This charming picture represents a performance at Mr. Conduitt's by a number of children of the play called "The Indian Emperor; or The Conquest of Mexico". It took place in 1731 before the Duke of Cumberland, Princess Mary, Princess Louisa, Lady Deloraine and her daughters, the Duke and Duchess of Richmond, the Earl of Pomfret, the Duke of Montague, Tom Hill, Captain Poyntz and Dr. Desaguliers. In *Hogarth Illustrated*, 1793, Vol. II, p. 331, is a key plate to the print. The actors were Lord Lempster (Cortes), Lady Caroline Lenox (Cydara), Lady Sophia Fermor (Almeria) and Miss Conduitt (Alibech), afterwards Lady Lymington.

Leslie describes it as "one of those early works painted from nature, the execution of which prepared the way to Hogarth's greater efforts." He goes on to say: "Three girls and a boy are on the stage, and seem to be very seriously doing their best, but the attitude and expression of one little girl on a front seat amongst the audience is matchless. She is so absorbed in the performance that she sits bolt upright, and will sit, we are sure, immovable to the end of the play, enjoying it as a child only can, and much the more, because the actors are children."

The performance takes place in a large room, richly decorated with pictures and statuary, and having a very important chimney-piece. The group is amazingly well conceived.

The picture was exhibited by the Earl of Upper Ossory in 1814. It was engraved by Robert Dodd, and published by Boydell's on January 1st, 1792.

References in writings: Austin Dobson's "Hogarth", pp. 200, 272.

PLATE XIX. The March of the Guards to Finchley. In the collection of The Governors of the Foundling Hospital. *Size of original:* 42 by 54 inches.

This picture was painted by Hogarth in 1746, and represents the march of the Guards towards Scotland in the year 1745 to quell the second Jacobite rising. It shows all the disorders of a sudden military dislodgment.

Hogarth at first, it is said, intended to dedicate it to George II, but as his request was received with anything but enthusiasm, the artist in a fume inscribed the print to the King of Prussia, as an encourager of Arts and Sciences, and His Majesty made fitting acknowledgment of the honour done him. It was sold by lottery, but Hogarth gave 167 chances to the Foundling Hospital, the fortunate chance, No. 1941, being amongst this group, so that Hospital won the picture; and the same night Hogarth himself delivered it to the Governors, in whose possession it has remained ever since. It was engraved by Luke Sullivan and published in December, 1750.

References in writings: Austin Dobson's "Hogarth", pp. 103, 204, 252, 158.

UNKNOWN ARTIST

PLATE XX. VIEW OF THE GREEN PARK, LONDON. In the collection of THE EARL SPENCER. *Size of original:* 30 by 50 inches.

This picture was painted about 1760, and shows Rosamund's Pond, Spencer House and Buckingham House. There are a great many figures in a delightful open-air scene, with swans on the water, and a view of the Abbey in the distance. It was at one time attributed to Hogarth, but is certainly not by him; and it is not easy to hazard a guess as to who could have painted it.

THOMAS PATCH

Patch was an English engraver, and it was in this sphere that his principal work was done, notably a series of twenty-six prints representing the frescoes in the Brancacci Chapel, and in other engravings after Italian masters. A few paintings by him are, however, known, including two accomplished landscapes at Hampton Court, showing the Arno at Florence by day and by night. Little is known of his life, except that for a time he was a pupil of Sir Joshua Reynolds, whom he accompanied to Italy, in which country he appears to have died shortly after 1774.

PLATE XXI. A GROUP IN FLORENCE. In the collection of THE DUCHESS OF ROXBURGHE. *Size of original:* 29¼ by 42⅜ inches.

This witty group includes Lord Roxburghe, who is seated in the centre, and probably the artist himself on the extreme right, holding up a design. It is more than an ordinary group, because many of the figures are evidently caricatures, with their facial peculiarities exaggerated. The scene is a room with a black and white marble floor. There are two girandoles on the wall, and between them is a picture of Florence and the bridge over the Arno, very much resembling that by Patch at Hampton Court. This picture was painted in 1774, and was probably one of the last Patch ever executed.

JOSEPH FRANCIS NOLLEKENS

Generally known as "Old Nollekens", this painter was the father of the better-known sculptor, Joseph Nollekens. Old Nollekens was a Fleming, born at Antwerp in 1702, who came over to England in 1733, and was for a while a pupil of Pieter Tillemans; but he is also known to have studied under Watteau and Panini, whose works he copied. He was patronised by Lord Cobham, who gave him commissions for several pictures at Stow, and he also painted many "composition pieces" for Lord Tilney, generally representing figures in the gardens at Wanstead, Lord Tilney's seat.

PLATE XXII. A MUSICAL PARTY. In the collection of CAPTAIN E. G. SPENCER-CHURCHILL. *Size of original:* 14 by 18 inches.

This is almost certainly one of the commissions that Nollekens executed for Lord Tilney, for it is a group of people enjoying music on the terrace at Wanstead House. They are seated near to the great double staircase of the house, on which are more than life-size statuary figures. Some are playing on instruments, and others listening and chatting. All are in rich costumes of varied colours, and close by is a negro boy in yellow with refreshments. The courtyard is of black and white marble, and on it lies some music, and a musical instrument, or perhaps the case for one.

FRANCIS HAYMAN

Hayman was born at Exeter in 1708, where he later became a pupil of the painter Robert Brown. Early in his career he made illustrations for books, including the works of Shakespeare, Milton, Pope and Cervantes, and as a result of the reputation he achieved in this sphere was commissioned by the proprietors of Vauxhall Gardens to execute a series of oriental decorations there. He was one of the foundation members of the Royal Academy, where he exhibited from

1769 to 1772, and was its librarian from 1771 to the time of his death in 1776. A friend of Hogarth and of Garrick, he earned considerable fame for himself not only as a painter but as a teacher, and was president of the Society of British Artists for the year 1776.

PLATE XXIII. RANELAGH. In the collection of MARY, COUNTESS OF ILCHESTER. *Size of original:* 33 by 56 inches.

An animated scene outside the entrance to this famous resort, probably painted at about the same time as the artist was executing his views of the rival gardens at Vauxhall.

PLATE XXIV. FAMILY GROUP. In the collection of THE VISCOUNT LEE OF FAREHAM. *Size of original:* 34¾ by 47¼ inches.

It is not known what family is represented in this pleasing group, but the quiet dresses, and the simple taste of the room in which it is depicted, invest it with something of the homely charm of earlier Dutch work.

ARTHUR DEVIS

Devis was born at Preston in about 1711, and died there in 1787. He exhibited at the Free Society of Artists between 1762 and 1780, but did not join either the Chartered Society or the Royal Academy. He was a pupil of Pieter Tillemans, from whom he acquired his technique in the painting of interiors and of small, neatly finished portraits.

PLATE XXV. TWO PORTRAITS OF MEMBERS OF THE SERGISON FAMILY OF CUCKFIELD. In the collection of LADY BROOKE. *Size of originals:* each 30 by 25 inches.

These two portraits, one outdoor and one indoor, are of members of the same Sussex family, and were doubtless executed at about the same time. They possess all the neatness of technique which we associate with Devis's work, and a minute precision of detail which is interesting and effective.

PLATE XXVI. TWO PORTRAITS: MISS MARY WARDEN, AFTERWARDS MRS. JOHN TOMLINSON, AND MISS SARAH WARDEN, AFTERWARDS MRS. CHARLES LANGFORD. In the collection of LADY BROOKE. *Size of originals:* each 30 by 25 inches.

Here again is an outdoor and indoor portrait of two members of the same family, though this time with female sitters. The rendering of the beautiful furniture in the portrait of Miss Sarah Warden is particularly detailed and accurate.

PLATE XXVII (left). MR. ORLEBAR. In the collection of THE VISCOUNTESS COWDRAY. *Size of original:* 19¼ by 13¼ inches.

A portrait of a richly dressed man leaning against a small bureau.

PLATE XXVII (right). TWO LITTLE MISS EDGARS. In the collection of THE VISCOUNT BEARSTED. *Size of original:* 34 by 40 inches.

These two children are standing on a terrace overlooking a park. The elder girl is holding out a bunch of grapes to the younger. It was this younger child who later married General Franck Hugonin, and to whose descendants the picture passed. It is said to have been painted in 1762, and may therefore be the picture of "Two Ladies with Grapes, etc., in a landscape" which Devis exhibited at the Free Society in 1763, No. 55. He exhibited another in 1761, No. 12, which is called simply "A Bunch of Grapes". It is therefore fairly safe to identify this painting with one of these two, which makes it practically the only one that can be identified with any certainty from those Devis exhibited between the years 1761 to 1780, the others being simply styled, "A Gentleman", "A Lady", "A Child", "A Portrait", and so on.

PLATE XXVIII. AN INCIDENT IN THE GROUNDS OF RANELAGH DURING A BAL MASQUÉ. In the collection of LIEUT.-COLONEL W. S. W. PARKER-JERVIS, D.S.O. *Size of original:* 50 by 40 inches.

The story of this picture is that the gentleman and lady were so attracted by one another during

the dance that they decided to unmask, when to their astonishment they found themselves to be husband and wife. They both look somewhat annoyed at the unsatisfactory surprise. The lady was a sister to the famous admiral John Jervis, Earl of St. Vincent.

PLATE XXIX (left). MR. AND MRS. RICHARD BULL OF NORTHCOURT. In the collection of JESSE ISIDOR STRAUSS, Esq. *Size of original:* 42 by 34 inches.

Mr. and Mrs. Bull are seated on either side of a round table, on which is set out a tea equipage. They are in a fine panelled room, with a beautifully carved architrave above the doorway, over which is an oval picture. There is also a fine carved chimney-piece, with a mantel-glass in an elaborate frame. On the mantelpiece are some pieces of blue and white china, and the mantel-glass appears to be set opposite to a window, as it gives a reflection of a distant, woody landscape.

PLATE XXIX (right). CHARLES CLAVEY WITH HIS WIFE, THREE CHILDREN AND BROTHER-IN-LAW, RICHARD BETTESWORTH. In the collection of HERBERT E. GRIFFITH, Esq. *Size of original:* 50 by 40 inches.

The scene is in the garden of their house at Hampstead, underneath a large overhanging tree, and Hampstead Heath can be seen in the background. Mr. Clavey is leaning against the tree near to which sits his wife, who was Martha Bettesworth. By her side is a baby child in a very long dress. In front of her, holding out his hands to her, is a boy, and, at the extreme right, is Mrs. Clavey's brother, Richard Bettesworth, with the third of the Clavey children, showing to his uncle some paper or sketch.

The picture was painted in 1754, and was therefore executed before Devis began to exhibit at the Free Artists.

PLATE XXX (above). A FAMILY OF ANGLERS: THE SWAINE FAMILY OF LAVERINGTON HALL IN THE ISLE OF ELY. In the collection of ARTHUR N. GILBEY, Esq. *Size of original:* 24½ by 39½ inches.

This picture was painted in 1749, before Devis began to exhibit at the Free Society of Artists. The family group seated beside a river forms a pleasing and successful composition.

PLATE XXX (below). MR. WILLIAM ATHERTON AND HIS WIFE LUCY. In the collection of THE LADY DARESBURY. *Size of original:* 36½ by 50 inches.

Mr. and Mrs. Atherton are depicted on their return from their honeymoon. They are in a fine panelled room, with a beautiful chimney-piece over which is a picture. There is a cabinet in the background, on which are set out pieces of blue and white china.

PLATE XXXI. HORACE WALPOLE PRESENTING KITTY CLIVE WITH A PIECE OF HONEYSUCKLE. In the collection of LADY MARGARET DOUGLAS. *Size of original:* 28 by 36 inches.

These two famous people are set against a delightful landscape vista of Twickenham and the Thames.

PLATE XXXII (above). MR. AND MRS. VAN HARTHALS AND THEIR SON. In the collection of THE VISCOUNT BEARSTED. *Size of original:* 35 by 47 inches.

This is a garden scene. Mr. Van Harthals is leaning upon the stump of a tree, and pointing out something to his wife, who is seated opposite to him, holding a spyglass on a tripod. Between them stands their son, holding a long pole, his hat on the ground beside him. In the distance is a stream, and a delightful landscape. The picture is signed and dated 1749, and was therefore a very early work, as Devis did not begin to exhibit at the Free Society of Artists until 1761.

PLATE XXXII (below). RICHARD MORTON, Esq., OF TACKLEY. In the collection of J. HASELTINE CARSTAIRS, Esq. *Size of original:* 28½ by 36 inches.

Mr. Morton is seated on a chair in his garden, while near by stands his nephew, and between them his niece Susan. The boy has a fishing rod in his hand, and his sister Susan carries a basket with some fish in it. In the distance is the river, and some fine trees in the park.

This picture is dated 1757, and therefore was painted before Devis began to exhibit at the Free Society.

SIR JOSHUA REYNOLDS

Reynolds was born at Plympton in Devonshire in 1723. The son of the head master of Plympton Grammar School, he was first apprenticed to an apothecary, but later came to London to study art under Thomas Hudson, then a popular portrait painter. In 1749 he sailed to Italy with Commander Keppel, where he spent three years in ardent study. He returned to London, where his work met with instant success, and in 1769 he took a leading part in the foundation of the Royal Academy, whose first President he was elected by acclamation. He founded the Literary Club in 1764, and was knighted in 1769. On his death in 1792 he was buried in the crypt of St. Paul's Cathedral.

PLATE XXXIII. SOME OF THE ARTIST'S FRIENDS. In the collection of JULIAN LOUSADA, Esq. *Size of original:* 23½ by 18 inches.

This group, painted in 1751, represents four of Sir Joshua's most intimate friends, Sir Charles Turner, Mr. Cooke, Mr. Woodyeare and Dr. Drake. One of the four, who is in grey, appears to be horrified at the notes that another is drawing from his 'cello, while of the other two, one is eagerly listening and the other playing on the flute.

The picture is painted boldly, not without a hint of caricature, and the colouring is in low tones. The whole conception is lively and witty, and we feel that the painter has been playing an amusing *jeu d'esprit* at the expense of his friends.

GEORGE STUBBS

Perhaps the most important painter of horses of the English school, Stubbs was born at Liverpool in 1724. Early in life he engaged himself to Winstanley, a Warrington artist, at that time employed by Lord Derby in copying pictures at Knowsley Hall, but after a while left him, deciding, to use his own words, "to look into Nature for myself, and consult and study her only." For a time he lived in York, pursuing anatomical studies, and later he travelled in Italy. He returned to Liverpool to begin his monumental work on "The Anatomy of the Horse", after which he retired to a lonely farm-house in Lincolnshire to complete it. Its publication in 1766 brought him an international reputation in the spheres both of science and of art.

He was President of the Society of Artists, but only an Associate of the Royal Academy. In 1781 he is said to have been elected a Royal Academician, but owing to a serious quarrel with the authorities of the Academy in that year, he withdrew his pictures, and the Academy rescinded his election. He was, however, it is said, legally elected, and he always styled himself an Academician. He died suddenly in 1806.

PLATE XXXIV. LORD AND LADY MELBOURNE, WITH SIR RALPH MILBANKE AND MR. JOHN MILBANKE. In the collection of THE LADY DESBOROUGH. *Size of original:* 39 by 60 inches.

A group of friends meet under the shade of a great tree. The two fine horses and the shaggy little pony that draws Lady Melbourne's cart are superbly drawn.

PLATE XXXV. COLONEL POCKLINGTON AND FAMILY. In the collection of MRS. CHARLES CARSTAIRS. *Size of original:* 50 by 40 inches.

A group of three figures and a horse, which the lady in the centre stoops gracefully to feed. The composition of the landscape background is very similar to that in the preceding picture.

JOHN ZOFFANY

Zoffany was born at Frankfurt-on-Main (not at Ratisbon as is generally stated) in 1725. He came to England about 1761, living for a while in the Grand Piazza at Covent Garden, and later in Lincoln's Inn Fields. He visited Florence, Vienna and Coblentz, executing commissions, and returned again to London. Shortly after this, in 1783, he left for India, where he painted some of his most important pictures, including the Impey and the Warren Hastings portraits. On his return to London, about 1789, he became one of the most important painters

of the day, and in 1794 was on the Council of the Royal Academy. In 1804 he travelled abroad again, though it is not quite clear what places he visited, and in that or the following year we hear of him at Canterbury. He died on the 11th November, 1810, and is buried in Kew church-yard, close to the tomb of Gainsborough.

The standard work on this artist was written by Lady Victoria Manners and Dr. G. C. Williamson, and was published in 1920.

PLATE XXXVI (left). PORTRAIT OF A MAN. In the collection of MARSHALL FIELD, Esq. *Size of original:* 30 by 25 inches.

PLATE XXXVI (right). THOMAS KING AS LORD OGLEBY. In the collection of the HONOUR-ABLE EVAN CHARTERIS. *Size of original:* 14 by 11 inches.

The actor is represented in the "Clandestine Marriage" by Colman and Garrick.

In former Exhibitions: R.A., 1908. *References in writings:* Manners & Williamson's "John Zoffany", p. 187.

PLATE XXXVII. SAMUEL BLUNT OF HORSHAM, AND WINIFRED HIS WIFE (*née* SCAWEN). In the collection of ARTHUR SCAWEN-BLUNT, Esq. *Size of original:* 30 by 32½ inches.

The existence of this picture was not known to the authors of the book on Zoffany.

PLATE XXXVIII. THE GENTLEMEN COMMONERS OF CHRIST CHURCH, OXFORD. In the collection of COLONEL RICHARD F. ROUNDELL. *Size of original:* 40 by 50 inches.

This group represents Mr. Richard Roundell (*circa* 1740-1772), Mr. (afterwards Sir) Henry Dashwood, Bart., of Kirklington Park (1745-1828), who is also represented in the Auriol group (*Plate LV*), the Honourable Thomas Noel, afterwards second Viscount Wentworth (*ob.* 1815), and Mr. Walter R. B. Hawkesworth (afterwards Fawkes) (1748-1792). These were all Gentle-men Commoners of Christchurch, Oxford, at the same time, and great friends. Mr. Hawkes-worth is on the right, Mr. Dashwood in the middle, Mr. Noel has his claret-coloured gown over his shoulders, and Mr. Roundell wears a similar claret-coloured gown which appears to be trimmed with velvet.

References in writings: John Zoffany, pp. 230-231.

PLATE XXXIX. JOHN, FOURTEENTH LORD WILLOUGHBY DE BROKE, WITH HIS WIFE AND THEIR THREE CHILDREN. In the collection of THE LORD WILLOUGHBY DE BROKE. *Size of original:* 39¼ by 49½ inches.

This very delightful group represents John, fourteenth Lord Willoughby de Broke, his wife Lady Louisa North, daughter of Francis, first Earl of Guildford and sister to Lord North, with their three children: John his successor, Henry, afterwards sixteenth Baron, who married Margaret, daughter of Sir John Williams, and Louisa, who married the Rev. Albert Barnard, Prebendary of Winchester, and became the mother of Robert John, the seventeenth Baron.

Lord Willoughby is leaning over the back of a chair on which Lady Willoughby is seated, and shaking his finger at the second child who is standing on the left side of the table and helping himself to a piece of hot buttered toast. Lady Willoughby is holding the youngest child, who stands with one foot on the table, against her right shoulder. The group is depicted in the breakfast room at Compton Verney. A fire is burning in the open grate, and over the richly carved mantelpiece is a landscape in the style of Joseph Vernet. The large and very handsome silver urn upon the tea table is still in the possession of the family.

In former Exhibitions: Birmingham, 1903, No. 62. Whitechapel, 1906, No. 31. *References in writings:* Manners & Williamson's "John Zoffany", p. 245.

PLATE XL. THE DUTTON FAMILY. In the collection of DANIEL H. FARR, Esq. *Size of original:* 40¼ by 50¼ inches.

This particularly charming picture, one of the best interior groups that Zoffany ever painted, was for a long time in the possession of Lord Sherborne, and the scene is the drawing-room at Sherborne Park, Gloucestershire. It is a group of four persons, Mr. and Mrs. Dutton, their son James, first Lord Sherborne, who married Miss Coke, and their daughter Jane, who married

Thomas Coke of Holkham, who afterwards became Earl of Leicester. Mr. Dutton and his son and daughter are seated round a mahogany card-table playing cards. Mrs. Dutton, who is seated by the fireplace reading, has for a moment put down her book to look at her son's cards, which he holds out to her. Mr. Dutton has turned away, apparently rather annoyed that his son should consult the mother respecting the play, while Miss Dutton is waiting, with evident impatience, for her brother to resume.

The story in the family is to the effect that Mrs. Dutton was reading the Bible, and objected either to the family playing cards at all or to being disturbed at that moment. There is a good view of the drawing-room, which is hung with numerous pictures, and has a carved and gilded girandole on the wall, and near to the fireplace a pole-screen, painted with flowers. The chimney-piece is a stately carved one of marble, and the walls of the room are green. Mr. Dutton is in purple, his son in greyish white with a yellow vest, his daughter in pale green.

In former Exhibitions: Royal Academy, 1907, No. 143. *References in writings:* Manners & Williamson's "John Zoffany", p. 233.

PLATE XLI. THE HONOURABLE CHARLES HOPE VERE WITH HIS SISTERS. In the collection of SIR HARRY VERNEY, K.C.V.O. *Size of original:* 33½ by 40 inches.

A portrait group of three persons: the Honourable Charles Hope Vere, youngest son of the first Earl of Hopetoun and great-grandfather of the present owner of the picture, in the scarlet uniform worn by the Archers for festival occasions, with his bow and arrows beside him, and a book in his hand; his sister, Lady Christian Graham, in a lavender dress and white cap, reading a copy of the *Gazette Extraordinary*, dated London, 1782, which contains a report of the Battle of Gibraltar, the first naval engagement in which the old gentleman's son, who afterwards became Admiral Sir George Hope, took part; and Lady Charlotte Erskine, afterwards Lady Mar, dressed in black with a white lace cap. On the pole-screen in the background is a view of the family seat of Blackwood, which still belongs to a branch of the family. The little round table in the foreground is now in Sir Harry Verney's possession.

Another group by Zoffany in the collection of the Marquess of Linlithgow depicts exactly the same persons in different attitudes, while there is a portrait of Mr. Hope Vere and one of his sisters in the collection of Mrs. Kerr-Lawson of Chelsea.

References in writings: Manners & Williamson's "John Zoffany", p. 239.

PLATE XLII. A GROUP OF CONNOISSEURS. In the collection of THE LORD O'HAGAN. *Size of original:* 34½ by 42½ inches.

In this group of six connoisseurs, Charles Towneley is resting both hands on his cane, Charles Price is seated, Dr. Verdun is holding a snuff-box and muff under his left arm, Dr. Oliver of Bath gazes at a marble fragment with fingers extended, and Richard Holt opens a curtain which Captain Wynn grasps. Dr. Price, who is the most prominent figure in the picture, is seated, gazing at the sculptured group through his spyglass.

This picture is believed to have been painted for the Society of Dilettanti, for membership to which body Towneley had intended to propose each of the persons represented; and on their election the picture would have been presented to the Society. He himself was under an obligation, as a member, to have his portrait painted and to present it, and he had to pay a fine year by year if he failed to do so. He must have paid this fine steadily, because the picture was never presented. This was probably due to pique on Towneley's part, because not one of his friends represented in the picture obtained the coveted distinction of being elected a member of the Dilettanti.

References in writings: Manners & Williamson's "John Zoffany", p. 223.

PLATE XLIII. CHARLES TOWNELEY AND HIS FRIENDS IN HIS LIBRARY. In the collection of THE LORD O'HAGAN. *Size of original:* 61 by 49 inches.

In this group Zoffany has painted Charles Towneley, the great collector, in his library, with his marbles, almost all of which are now in the British Museum. He is in conversation with D'Ankerville, near whose chair stand, talking together, Charles Greville and Thomas Astle. Nollekens alludes to the painting of this picture, and says: "The best of the marbles were brought into the painting room to the artist, who made them up into a picturesque composition accord-

ing to his own opinion." He adds: "The likeness of Mr. Towneley is extremely good. He looks like the dignified possessor of such treasures. At his feet lies his faithful dog Kam, a native of Kamschatka, whose mother was one of the dogs yoked to the sledge which drew Captain King to that island." The library was at 7 Park Street, Westminster, now 14 Queen Anne's Gate, and Zoffany had marbles brought from various parts of the house into the library, at the end of which is a bookcase full of books, in order that he might depict as many as possible in the room.

Formerly exhibited at Royal Academy, 1790. Royal Institute, 1814, No. 92 and 1849, No. 124. Burlington Fine Arts Club, 1907, No. 25. *References in writings:* Manners & Williamson's "John Zoffany", p. 223.

PLATE XLIV (above). A MAN AND TWO BOYS, ONE WITH A KITE. In the collection of SYDNEY HERBERT, Esq., and MICHAEL HERBERT, Esq. *Size of original:* 39 by 49 inches.

It is unfortunate that the names of the persons depicted in this particularly charming group are unknown. The picture was bought by Mr. Martin Colnaghi at Christie's, in June, 1900, for £105. It was sold by him to Mr. Friedlander, who bequeathed it to the Hon. Mrs. Goldman of Chiswick.

Formerly exhibited by Zoffany at the Society of Artists in 1764, No. 141, where it was simply entitled "A Family". *References in writings:* Manners & Williamson's "John Zoffany", pp. 201-202.

PLATE XLIV (below). LORD NUGENT AND HIS FAMILY, WITH THE HORSE GUARDS' PARADE IN THE DISTANCE. In the collection of SIR GEORGE GUY BULWER NUGENT, BART. *Size of original:* 42 by 49½ inches.

The elderly man in the picture is Robert, Earl Nugent when Viscount Clare. Advancing towards him is his son by his first wife, Edmund Nugent, Lieutenant-Colonel in the 1st Foot Guards, who died unmarried in Bath in 1771. The child who is dancing forward towards Colonel Nugent, almost on the point of falling off the table upon which she is standing, is Mary Elizabeth, Earl Nugent's eldest daughter by his third wife. She eventually married George, Marquess of Buckingham, and he inherited, under special limitations, the Earldom of Nugent. Near to the child, and resting one hand upon the table by its foot, stands Miss Mary Nugent, Earl Nugent's half-sister, known to the family as "Aunt Peggy". Behind Colonel Nugent in the distance can be seen the Horse Guards' Parade.

Formerly exhibited at Royal Academy, 1765. *References in writings:* Manners & Williamson's "John Zoffany", p. 223.

PLATE XLV. CAPTAIN JOHN AUGUSTUS HERVEY TAKING LEAVE OF HIS FAMILY ON HIS APPOINT-MENT TO THE COMMAND OF A SHIP. In the collection of THE MARQUESS OF BRISTOL. *Size of original:* 39½ by 49 inches.

The group represents Lord Mulgrave and Lady Mulgrave, Lady Mary Fitzgerald, Mr. George Fitzgerald, Captain Hervey (afterwards Marquess of Bristol), and Lady Hervey. There is a view of the sea through an archway, with the ship of which Captain Hervey is about to take command.

Formerly exhibited at R.A., 1891, No. 97. *References in writings:* Manners & Williamson's "John Zoffany", pp. 183-184.

PLATE XLVI. THE DRUMMOND FAMILY. In the collection of GEORGE H. DRUMMOND, Esq. *Size of original:* 41 by 63 inches.

Mr. Andrew Drummond is seated under a tree. Beside him is his daughter-in-law, Charlotte, the daughter of Lord William Beauclerk and the wife of his only son, John Drummond. Beyond her stands their daughter Charlotte, who later married the Rev. Henry Beauclerk, while on the extreme right of the picture stands her brother George, who afterwards married Martha, the daughter of Thomas Harley, son of the third Earl of Oxford.

On the left of the picture, Mr. John Drummond, M.P., is seen talking to his youngest son, John, who is being held on a pony. Nearby, on horseback, is Mr. John Drummond's daughter, Jane Diana, who afterwards married Mr. R. Bethell Cox.

The picture, which was painted at Stanmore in Middlesex, is one of Zoffany's happiest outdoor Conversation groups, and represents three separate generations. Old Mr. Drummond is said to have walked up from Glasgow to London to found the business which eventually became Drummond's Bank, using the gold-headed walking-cane seen in the picture. The cane is still preserved in a glass case at Drummond's Bank.

References in writings: Manners & Williamson's "John Zoffany", pp. 192-193.

PLATE XLVII. THE GRAHAM FAMILY. In the collection of SIR GUY GRAHAM, BART. *Size of original:* 40 by 50 inches.

In this family group, Sir Bellingham Graham, the fifth Baronet (1729-1790), is seated under a tree in the park, which ever since the picture was painted has been known as the "Zoffany Tree". His son Bellingham, afterwards the sixth Baronet, stands near by, with Elizabeth, a daughter, who married John Smith in 1765. Behind her, nearer to the tree, is Catherine, another daughter, who married Henry Francis Fulk Greville in 1766. The family possesses a sketch for the portrait of Sir Bellingham Graham, and also a sketch for the portrait of the housekeeper at Stanton Conyers, where the picture was painted, a well-known character of the day, known as Mistress Ellis, whom Zoffany very much admired by reason of her skill in the preparation of wonderful dishes and sweetmeats, with which she fed him amply when he was staying at the house. In return for her consideration, he painted her portrait. The present picture was painted, it is said, in 1780.

Formerly exhibited at R.A., 1878, No. 230. *References in writings:* Manners & Williamson's "John Zoffany", p. 202.

PLATE XLVIII. THREE CHILDREN BLOWING BUBBLES. In the collection of A. P. CUNLIFFE, Esq. *Size of original:* 20¼ by 25¾ inches *(oval)*.

This picture was engraved in colours by Martindale. It is very unfortunate that the children in it cannot be identified.

References in writings: Manners & Williamson's "John Zoffany", p. 189.

PLATE XLIX. A FAMILY PARTY. THE MINUET. In the possession of THE CORPORATION OF GLASGOW. *Size of original:* 39 by 49 inches.

This delightful group represents a family, two members of which are dancing a minuet to the music of a flute. The picture is unusual in its general characteristics, and must almost certainly have been painted under the influence of Watteau, whose work, it is well known, Zoffany particularly admired.

The tradition in the Zoffany family was that the son played the flute so exceedingly badly that the artist insisted upon his stopping the music while the painting was in progress, promising to put the flute in afterwards. It is said that the flute is not held in the proper position, and that the artist was afterwards upbraided by the flautist on this account. The picture was purchased by its present owners from the McLellan Gallery in 1854.

References in writings: Manners & Williamson's "John Zoffany", p. 161.

PLATE L. GEORGE, THIRD EARL COWPER, COUNTESS COWPER AND THE GORE FAMILY. In the collection of THE LADY DESBOROUGH. *Size of original:* 30 by 38 inches.

The group depicts George, third Earl Cowper, his wife, Mr. and Mrs. Gore, and their two daughters. Countess Cowper was a daughter of Charles Gore, of Southampton, who was perhaps the original of Goethe's "Travelled Englishman" in *Wilhelm Meister*. Mrs. Delany, in one of her amusing letters, mentions the meeting of Lord Cowper and Miss Gore, "when little Cupid straightway bent his bow". The marriage took place at Florence, and Horace Walpole condoled with Sir Horace Mann on the prospect, as Mann would probably lose very much of the society of his old friend. Lady Cowper and her husband were highly popular at the court of the Grand Duke of Tuscany, and were considered as ornaments to that brilliant, but by no means strait-laced society. Miss Berry refers in very high terms to Miss Gore, who resided with her married sister. There were three children by the marriage.

The picture was painted by Zoffany at the Villa Palmieri in Florence. It belonged to Lord Cowper, but disappeared after Lady Cowper's death in 1826, when it was strongly suspected

that it was stolen with many other objects of value. Some twenty years later Mr. Spencer Cowper saw it on sale at an antiquary's in Florence, and bought it for twenty pounds for his brother, the sixth Earl Cowper.

Formerly exhibited at Second National Loan Collection, Grosvenor Gallery, No. 80, Catalogue, p. 94. Whitechapel Gallery, 1908, No. 157. *References in writings:* Manners & Williamson's "John Zoffany", pp. 191 and 192.

PLATE LI. THE ARTIST, HIS WIFE, THEIR CHILDREN AND A NURSE. In the collection of MRS. O. BENWELL. *Size of original:* 30 by 42 inches.

This interesting group, which was painted for the family and has never left its possession, belonged until recently to Mrs. Everard Hesketh. Zoffany, who is depicted in old age, is seated in about the centre of the picture. One of his daughters is playing on a harpsichord, and another on a harp. The two younger children are at each end of the group, and their figures are only lightly sketched in, and have never been completed. In the background is the figure of the old nurse, Mrs. Ann Chase, who died in 1810, at the age of eighty-one, and is buried at Kew in the same grave as Mrs. Zoffany. In her arms she is carrying one of the children.

Zoffany never had more than four children living at once, and the tradition respecting this picture is somewhat complex. By some members of the family it is thought that the child in the arms of the nurse is an imaginary representation of the little boy who died as an infant, but others state that this is the youngest child, afterwards Mrs. Oliver, and that the third girl is twice represented. There are certainly five children in the group, and there is a family tradition that Zoffany forgot that he had already painted one daughter, and sketched her in rapidly as she left the room, thinking that she was not in the picture. There is not the smallest question as to its representing Zoffany, his family, and the nurse, for the tradition has been handed down unimpaired.

References in writings: Manners & Williamson's "John Zoffany", p. 204.

PLATE LII. A MUSIC PARTY ON THE THAMES AT FULHAM. In the collection of MISS OLIVE LLOYD-BAKER. *Size of original:* 45 by 49 inches.

In this group thirteen members of the Sharp family are represented on their yacht on the Thames at Fulham. The figures are as follows:

(1) Dr. John Sharp (1693-1758), the eldest brother, Prebendary of Durham, Archdeacon of Northumberland. He is in the right corner. He was Almoner to Queen Anne.

(2) His wife Mary, daughter of Dr. Dering, Dean of Ripon. She is behind her husband.

(3) Anna Jemima, their only child, is on the right at the top.

(4) William Sharp, who is steering, and for whom the picture was painted, a surgeon who declined a baronetcy offered him by George III for successful attendance on Princess Amelia. He is at the top of the picture wearing the Windsor uniform, and is waving his hat.

(5) His wife Catharine, daughter of Thomas Berwick, Esq. She is in a riding-habit, and just below her husband.

(6) Mary, their only child, carrying a kitten on her lap. She married the owner's grandfather, T. J. Lloyd-Baker, and was the only person in the family to leave descendants.

(7) James Sharp, a skilful engineer, represented holding a musical instrument called a serpent.

(8) His wife Catharine, daughter of John Lodge. She is seated by Mrs. William Sharp.

(9) Catharine, their only surviving child.

(10) Elizabeth, Mrs. Prowse, the widow of George Prowse, Esq., of Wichen Park, Northampton, and Berkeley. She is seated at the harpsichord. Her estate after her decease went to her husband's nephew, Sir Charles Mordaunt, and his descendant sold Berkeley to Lord Bath and Wichen to Lord Penrhyn.

(11) Judith Sharp, sister of Mrs. Prowse, seated next to Jemima, her sister, wearing a riding-habit and holding a lute.

(12) Frances Sharp, her youngest sister, holding a piece of music.

(13) Granville Sharp, the philanthropist, represented handing a piece of music to Mrs. Prowse; close by him is a double flageolet.

Also depicted in the picture are the boatmaster, the cabin-boy, and Zoffany's favourite dog, Roma, while other instruments shown in the group are the oboe and the theorbo. The church in the background is that of Fulham, and on the right can be seen the balconied cottage belonging to William Sharp, but usually inhabited by Granville. It communicated by an underground passage with Fulham House, where William Sharp lived. George III and Queen Charlotte on many occasions went to drink tea with the Sharp family on their yacht in order to listen to their singing and playing.

The information respecting the identity of the various persons was derived from the cabin-boy, who was still living in 1848, within the recollection of Mr. Lloyd-Baker, and who remembered the work being done, and described the various persons on the yacht. The picture is said to have cost the family eight hundred guineas. A copy of it is in the possession of Mrs. Battine, of St. Hilary, Bexley.

Formerly exhibited at R.A., 1781, and again in 1879, No. 27. Whitechapel Exhibition, 1906, No. 148. *References in writings:* Manners & Williamson's "John Zoffany", p. 71.

PLATE LIII. The Family of Sir William Young, Bart. In the collection of The Right Hon. Sir Philip Sassoon, Bart., M.P. *Size of original:* 44 by 66½ inches.

Sir William Young was created a Baronet in 1769, and was Governor of St. Vincent and Dominica. One of his daughters was named Mary, and is said to be the girl in yellow seated on the stone pedestal. An almost identical portrait of these two figures alone was also painted by Zoffany, and belongs to the present Lady Young. She has furthermore a separate picture of the group of the man on horseback with the child in front of him, the negro attendant, and the boy in canary yellow, embracing the white dog. It would therefore appear that, after painting the large group, Zoffany was instructed to reproduce the groups at the two ends of it separately. Lady Young's pictures measure 33 by 25 inches the horseback group, and 25 by 19 inches the boy and girl group. The boy in this group was William Young, afterwards the second Baronet, later Governor of Tobago.

References in writings: Manners & Williamson's "John Zoffany", p. 247.

PLATE LIV. Sir Elijah and Lady Impey and their Family. In the collection of Edward Impey, Esq. *Size of original:* 36 by 48 inches.

The sketch for the head of the portrait of Sir Elijah Impey is now in the National Gallery. Zoffany painted another portrait of Lady Impey, full length, seated with a dog in her arms. This group was, of course, painted in India.

References in writings: Manners & Williamson's "John Zoffany", p. 207.

PLATE LV. The Auriol Family. In the collection of M. G. Dashwood, Esq. *Size of original:* 56 by 78 inches.

This large group, also painted in India, represents different members of the Auriol family. In the centre are two ladies, Charlotte, afterwards Mrs. Thomas Dashwood, and Sophia, afterwards Mrs. John Prinsep, seated at a round table drinking tea. Nearby is Thomas Dashwood, the second son of Sir James Dashwood, of Kirklington, Oxford, playing chess, and on the opposite side stands his companion, James Auriol. At the opposite end of the picture are three men, two standing and one seated, and behind them a native servant holding a pipe. The standing figures are Charles Auriol and John Auriol, while the seated figure is John Prinsep, the other son-in-law. A number of native servants are waiting at the tea-table.

There is a replica of this picture known to exist, which at one time belonged to Mrs. Praed at Gloucester Place, Portman Square.

References in writings: Manners & Williamson's "John Zoffany", pp. 189, 190.

PLATE LVI. John, Third Duke of Atholl, and his Family on the Banks of the Tay at Dunkeld. In the collection of His Grace The Duke of Atholl. *Size of original:* 63 by 36 inches.

The painting was executed to fit over a carved mantelpiece at Blair Castle. The background, which represents the Tay and the hill Craig Venian, with the Atholl Cairn, appears to be the work of Charles Stewart (brother of Anthony Stewart, 1773-1846, the miniature painter), who was at that time on Tayside, painting for the Duke of Atholl a series of landscapes which now form five panels in the dining-room, and are signed by him and dated 1766, 1767, 1768, 1777 and 1778. It would appear that the canvas, having been prepared for the exact place in the room, had the landscape painted upon it by Stewart, and then was brought up to London so that Zoffany could carry out his work from sittings when the members of the family were in town. Entries in the Duke's account-book read thus:

"1765.
 June. Mr. Zophany, in part payment for a family picture £100
1767. February. To Mr. Zoffany, Painter, for a family picture of nine figures, at
 twenty Guineys each, but £100 being paid formerly, I only pay
 him now 89
 £189

The receipt from the painter is still in existence, and reads thus:

"London, 16th Jan., 1767

"Received from the Duke of Atholl, Eighty Nine Pounds, that, with One Hundred Pounds formerly Received Makes In All One Hundred and Eighty Guineys, being in full for a Family Picture of Nine Figures at Twenty Guineys Each."

The painting is signed "Johan Zoffany", and dated 1767.

Former Exhibitions: The picture was not exhibited till 1769 and then at the rooms of the Society of Artists. It is described in the catalogue under No. 215. *References in writings:* Manners & Williamson's "John Zoffany", pp. 15, 16 and 174.

PLATE LVII. Mr. and Mrs. Garrick Entertaining Dr. Johnson to Tea. In the collection of The Earl of Durham. *Size of original:* 40 by 51 inches.

In this group Mr. and Mrs. Garrick are represented at tea at Garrick's Villa at Hampton. They are entertaining Dr. Johnson, who is seated on a chair a little apart from the others. Mrs. Garrick is at the tea-table and near her are two dogs. Garrick stands behind her, and Mr. Bowden is also seated in the group. His three-cornered hat lies on the ground, and a third dog lies near to it. He is pointing to George Garrick, who is standing close to the river fishing. The scene is on the banks of the Thames, and there are trees and houses in the distance. The picture was purchased by the second Earl of Durham at Garrick's sale for £25.

References in writings: Manners & Williamson's "John Zoffany", p. 195.

PLATE LVIII. Mr. and Mrs. Garrick on the Steps of Shakespeare's Temple at Hampton. In the collection of The Earl of Durham. *Size of original:* 40 by 51 inches.

This depicts Shakespeare's Temple at Chiswick, sometimes called "Pope's Villa", with Mr. and Mrs. Garrick standing on the steps. Garrick has a stick in his hand with which he is pointing to his brother. Mrs. Garrick holds a fan. There is a child standing on the top of the steps, leaning against one of the columns, and near by is a servant bringing in some food. Close to the river bank stands a man fishing, almost certainly George Garrick, while between him and the figures of Garrick and his wife a very large St. Bernard dog is lying on the grass, probably "Dragon", the dog to whom Hannah More addressed an ode. The picture is believed to have been purchased at Garrick's sale by the second Earl of Durham for £25.

References in writings: Manners & Williamson's "John Zoffany", p. 195.

PLATE LIX. THE DRUMMOND FAMILY AT CADLAND. In the collection of THE HONOURABLE MRS. WALTER LEVY. *Size of original:* 58 by 94 inches.

In this group, Robert Drummond, with his wife and children, are represented in the grounds at Cadland, looking towards the Isle of Wight. Robert Drummond, who was a nephew of Andrew Drummond, the banker (see Plate XLVI), stands in the centre under a tree with his eldest son Andrew, who points out to sea with a telescope. On the left is Mrs. Drummond, giving flowers to her daughter Charlotte. The other children are sons, and the golf club and ball held by the boy on the left form one of the earliest pictorial records of the game in England. The picture was formerly in the collection of Lord Wandsworth as an unidentified family group, and was exhibited by Messrs. Spink in 1925.

References in writings: "Country Life", October 24th, 1925. Plate XVIII.

PLATE LX. THE COLMORE FAMILY. In the collection of THE RIGHT HONOURABLE SIR PHILIP SASSOON, BART., M.P. *Size of original:* 39½ by 50 inches.

An exceedingly fine group of a man and his wife with their four children, and the grandmother, seated on a bank beneath a large overshadowing tree. This picture was unknown to the authors of "John Zoffany".

PLATE LXI. SAMUEL FOOTE AS MAJOR STURGEON AND HAYES AS SIR JACOB JOLLOP IN "THE MAYOR OF GARRATT". In the collection of MRS. DAVID GUBBAY. *Size of original:* 21¼ by 34¼ inches.

The two actors are represented in a scene from the play "The Mayor of Garratt", by Foote, and this is the picture to which Horace Walpole refers when he writes: "Mr. Foote in the character of Major Sturgeon in 'The Mayor of Garratt' (and Mr. Baddeley), a very fine likeness, a picture of great humour". Walpole must surely have been mistaken as to the identity of Baddeley, for all authorities are unanimous that it is Hayes who is represented. Zoffany's love of detail is quaintly shown, for the scene is placed in the house of Sir Jacob Jollop, and the painter has depicted a row of four boxes inscribed with the initials "J. J." There is also a map of London on the wall.

This picture was engraved in mezzotint by J. Haid, and the print was published by Boydell in 1765.

Lord Carlisle has an exact replica of it, also by Zoffany, and it is therefore uncertain which of the two was exhibited at the Society of Artists in 1764.

References in writings: Manners & Williamson's "John Zoffany", p. 186.

PLATE LXII (*above*). DAVID GARRICK AND MRS. CIBBER IN "VENICE PRESERVED". In the collection of THE EARL OF DURHAM. *Size of original:* 40 by 51 inches.

In this picture Garrick and Mrs. Cibber are seen in "Venice Preserved", as Jaffier and Belvidera. The scene is Venice at night, with water, moonlight, and a lighted lamp on the pavement. Garrick holds a dagger, and Mrs. Cibber kneels before him.

Formerly exhibited at R.A., 1763. *References in writings:* Manners & Williamson's "John Zoffany", p. 194.

PLATE LXII (*below*). MACKLIN AS SHYLOCK. In the collection of THE MARQUESS OF LANSDOWNE. *Size of original:* 45 by 57 inches.

Macklin is here represented on what was probably his last stage appearance, as at the time he was ninety years old. The figure at the extreme left of the group, wearing a wig, is that of the Earl of Mansfield.

Formerly exhibited at R.A., 1884, No. 54. National Portrait Gallery, 1867, No. 806. *References in writings:* Manners & Williamson's "John Zoffany", p. 213.

PLATE LXIII. DAVID GARRICK AND MRS. CIBBER IN "THE FARMER'S RETURN". In the collection of THE EARL OF DURHAM. *Size of original:* 40 by 51 inches.

In this group, Garrick is represented seated in the centre smoking a pipe, while Mrs. Cibber stands looking at him in some astonishment, with a jug in her hand. The play was from Garrick's own pen.

Formerly exhibited at R.A., 1762. *References in writings:* Manners & Williamson's "John Zoffany", p. 194.

PLATE LXIV. DAVID GARRICK AS ABEL DRUGGER. In the collection of THE HONOURABLE GEOFFREY HOWARD. *Size of original:* 40 by 50 inches.

In this group Garrick, as Abel Drugger, is shown with Burton and Palmer in Ben Jonson's "The Alchemist", Act II, Scene 6. Walpole wrote of the picture: "This most excellent picture of Burton and J. Palmer and Garrick as Abel Drugger is one of the best pictures ever done by this Genius. Sir Joshua Reynolds gave him £100 for it. Lord Carlisle offered the latter twenty guineas more for it. Sir Joshua said he should have it for the £100, if his Lordship would give the £20 to Zoffani, which he did."

This story is confirmed by Mary Moser, who wrote, so Smith tells us, to Fuseli *apropos* that year's exhibition at the Academy. "Zoffany," she says, "was superior to everybody in a portrait of Garrick in the character of Abel Drugger, with two other figures, Subtile and Face. Sir Joshua agreed to give a hundred guineas for the picture. Lord Carlisle half an hour after offered Reynolds twenty to part with it, which the knight generously refused, resigned his intended purchase to the Lord, and the emolument to his brother artist. (He is a gentleman!)"

This practice, we are told in *The Literary Gazette* for July 8th, 1826, which gives an account of the transaction, was one not infrequently employed by Reynolds to add to the emoluments of other artists whose work he admired. In that journal one hundred and fifty guineas is mentioned as the sum ultimately paid by Lord Carlisle, and this is confirmed by a tradition at Castle Howard to that effect. Since Walpole and Mary Moser were probably only reporting hearsay, it is probable that the latter figure is the correct one. Lord Carlisle was a great admirer of Zoffany's, several of whose works he purchased.

Formerly exhibited at R.A., 1770. R.I., 1814, No. 80, 1840, No. 81. Whitechapel, 1906, No. 125, 1910, No. 32. Grafton Galleries, 1897, No. 97. Guelph, 1891, No. 361. *References in writings:* Manners & Williamson's "John Zoffany", pp. 26, 27 and 186.

PLATE LXV (left). MRS. SALUSBURY. In the collection of THE MARQUESS OF LANSDOWNE. *Size of original:* 50 by 39¼ inches.

The lady is standing in a paved room, and in her right hand, which is resting on the back of a chair, she holds a parchment document with a seal. This picture was discovered at Tully Allen, where it had been taken by Lady W. Osborne Elphinstone, whose mother, Lady Keith, was the daughter of Thrale, and the granddaughter of Mrs. Salusbury. In a letter from Mrs. Piozzi from Weston-super-Mare, dated October 18th, 1819, she wrote respecting this picture: "My mother's portrait by Zoffany should go to Lady Keith, who alone of my family can remember her."

References in writings: Manners & Williamson's "John Zoffany", p. 213.

PLATE LXV (right). MR. AND MRS. PALMER AND THEIR DAUGHTER. In the collection of THE HONOURABLE FREDERIC WALLOP. *Size of original:* 36 by 28 inches.

The group represents Mr. and Mrs. Palmer and their daughter, afterwards Mrs. Landon of Dorney Court, Bucks. She is having a drawing lesson from her father, while Mrs. Palmer is engaged in some needlework. All three persons are seated at a round table. This picture was sold at Christie's in 1902 for £199 10s.

References in writings: Manners & Williamson's "John Zoffany", p. 155.

PLATE LXVI (above). SAMUEL SMITH AND HIS SON WILLIAM SMITH. In the collection of FRANK TRAVERS, Esq. *Size of original:* 34 by 42 inches.

The picture represents Mr. William Smith (1756-1835), the member for Norwich, when a boy, with his father, Samuel Smith, then head of the firm known as Travers & Co., in which he was succeeded by his son. The boy, who is looking towards his father, is apparently sketching, one hand resting upon an open sketch-book, while with the other he appears to be dipping his pen into Indian ink. Nearby is a pair of dividers. The firm of Travers & Co. is said to have been the first to have brought Indian ink from China into commercial use. Though for many years it had been possible to acquire this in very small quantities at an exceedingly high price, Travers were the first firm to sell it at a fairly moderate price; hence Zoffany was anxious to introduce this commodity into the picture. The picture is referred to in a privately printed work, issued by Messrs. Travers & Co., entitled "Past and Present in an Old Firm". It was originally painted for Mr. Smith, and has never since left the family.

References in writings: Manners & Williamson's "John Zoffany", p. 236.

PLATE LXVI (*below*). THE REVEREND EDWARD AND MRS. HUNLOKE. In the collection of THE HONOURABLE MRS. WALTER LEVY. *Size of original:* 25 by 30 inches.

Mr. Hunloke, dressed in the dark suit and clerical wig of the period, sits at a table with his young wife who holds their newly-born baby in her lap.

PLATE LXVII (*above*). THE REVEREND JOHN COCKS AND JAMES COCKS. In the collection of THE HONOURABLE ESMOND HARMSWORTH. *Size of original:* 28 by 36 inches.

The group represents the Reverend John Cocks (1731-1793) and his brother, James Cocks (1734-1804), the third and the fifth sons of John Cocks of Castleditch. The elder brother is in clerical attire, with silk gown, wig and wrist-bands. The picture is inscribed with the names of the sitters and the words "Zoffany pinxit" in a later hand.

References in writings: Manners & Williamson's "John Zoffany", pp. 203, 204.

JOHN HAMILTON MORTIMER

This artist was born at Eastbourne in Sussex in 1741, the son of the Collector of Customs at that port. Determining to become an artist, he was sent to London and placed as a pupil under Hudson, but he appears to have spent the greater part of his time drawing from the casts exhibited by the Duke of Richmond in his gallery, where he was encouraged and assisted by Cipriani. In competition with Romney, Mortimer gained a premium of a hundred guineas, offered by the Society of Arts, for his painting of "St. Paul Converting the Britons", which picture was presented in 1770 to the Church of Chipping Wycombe, Buckinghamshire. He was a member of the Society of Artists and was elected Vice-President of that body in 1773. In 1779, without any expectation on his part, he was created a Royal Academician on the particular request of the King, but he did not live to receive his diploma, as he died, after an illness of a few days, in the same year.

It is quite likely that Mortimer was responsible for some pictures attributed to Zoffany, though his work is harder, more definite and crude, and generally less agreeable than that of the other painter.

PLATE LXVII (*below*). THE BOOTH FAMILY. In the collection of THE VISCOUNT BEARSTED. *Size of original:* 39½ by 48 inches.

The picture represents the Rev. Charles Everard (afterwards Booth), his son, and a friend, in the billiard-room at Twemlow Hall, Cheshire. The clergyman is seated in a chair, covered with a green and white material, almost identical with that used by Zoffany in his groups of the Cocks family. Both the son and the friend are holding billiard cues.

THOMAS GAINSBOROUGH

Gainsborough was born at Sudbury in Suffolk in 1727, died in 1788 and was buried at Kew. He studied under Gravelot and Francis Hayman, and resided for some years in Ipswich, where he became acquainted with Philip Thicknesse, his first biographer, at whose suggestion he went to Bath, where he remained from 1760 to 1774. He was elected an original member of the Royal Academy in 1768, and exhibited there in the following year, and until 1772. In 1774 he came to London and settled down at Schomberg House in Pall Mall, attaining great fame, and becoming the favourite painter of the King and the Royal Family.

PLATE I (*Frontispiece*). THE ARTIST, HIS WIFE, AND CHILD. In the collection of SIR PHILIP SASSOON, BART., M.P. *Size of original:* 36 by 28 inches.

Gainsborough and his wife are seated in a landscape, and the group is one of the ablest that the painter ever executed. One hand rests on his hip, while in the other he holds a drawing. Mrs. Gainsborough is seated by his side, and between them is their elder girl Mary. In the foreground is a dog drinking water from a pool.

The picture was painted about 1751.

In previous collections: The late Rev. E. Gardiner, great-nephew of Thomas Gainsborough, Mrs. Harward, of Clevedon, Somerset, widow of the late Edward Netherton Harward, a great-grand-nephew of the artist. Mr. D. H. Carstairs of New York. *Formerly exhibited* at Grosvenor Gallery, Gainsborough Exhibition, 1885, No. 195. Independent Gallery, Old Masters Exhibition, 1925, No. 12. Gainsborough Memorial Exhibition, Ipswich, 1927, No. 16. *References in writings:* Sir Walter Armstrong's "Gainsborough", 1904, p. 266. Sir Walter Armstrong's "Gainsborough", 1899 edition, p. 195. "Studio", August 1923, in the article "The Gainsborough Family Portraits" by William T. Whitley, and there reproduced in colour as frontispiece.

PLATE LXVIII (above). JOHANN CHRISTIAN BACH, SON OF JOHN SEBASTIAN BACH. In the collection of THE DOWAGER LADY HILLINGDON. *Size of original:* 10 by 9 inches.

PLATE LXVIII (below, left). MEDALLION PORTRAIT OF A GENTLEMAN. In the collection of THE DOWAGER LADY HILLINGDON. *Size of original:* 5½ by 4¼ inches (*oval*).

PLATE LXVIII (below, right). MEDALLION PORTRAIT OF SIR J. BASSETT. In the collection of THE DOWAGER LADY HILLINGDON. *Size of original:* 5¼ by 4 inches (*oval*).

PLATE LXIX (left). GIOVANNA BACCELLI THE DANCER. In the collection of SIR ALFRED BEIT, BART. *Size of original:* 22 by 15½ inches.
There is a larger version of the same picture in existence.
Formerly exhibited at Agnew's Gallery, London, 1896. Agnew's Gallery, Paris, 1900. Agnew's Gallery, Berlin, 1908. Gainsborough Memorial Exhibition, Ipswich, 1927, No. 72.

PLATE LXIX (right). A YOUNG LADY SEATED IN A LANDSCAPE. In the collection of SIR HERBERT COOK, BART. *Size of original:* 28½ by 25½ inches.

PLATE LXX. MR. AND MRS. BROWN OF TRENT HALL. In the collection of THE RIGHT HONOURABLE SIR PHILIP SASSOON, BART., M.P. *Size of original:* 33 by 55½ inches.
A brilliant example of Gainsborough's early manner. The view is of Spixworth Park, Norfolk.

PLATE LXXI. ROBERT ANDREWS AND HIS WIFE. In the collection of G. W. ANDREWS, Esq. *Size of original:* 27½ by 47 inches.
Another remarkable work in Gainsborough's early manner. It was painted at Auberies near Sudbury. Mr. Andrews is standing by his wife, who is seated in a garden chair. They are overlooking a cornfield, and there is a landscape with trees in the distance.
Formerly exhibited at the Gainsborough Memorial Exhibition, Ipswich, 1927, No. 26. *References in writings:* Sir Walter Armstrong's "Gainsborough", 1904, p. 257.

PLATE LXXII (above). THE MINUET. In the collection of LIEUT.-COLONEL GILES H. LODER. *Size of original:* 24 by 36 inches.

HUGH BARRON

Very little is known of this artist, except that he was the son of an apothecary in Soho, born *circa* 1745. He entered the studio of Sir Joshua Reynolds, and appears to have worked under that master for some years. He then went to Lisbon and to Rome. He exhibited at the Royal Academy between 1783 and 1786, and died in 1791.

PLATE LXXII (below). THE CHILDREN OF GEORGE BOND OF DITCHLING. In the collection of THE HONOURABLE FREDERIC WALLOP. *Size of original:* 40 by 50 inches.
This is a pleasingly conceived group, although the figures are perhaps spread out in a somewhat long line. They are the children of George Bond, of Ditchling, Romford, Essex, and the picture was painted in 1768.

JOHN SINGLETON COPLEY

This important painter was born of English and Irish parentage at Boston, Massachusetts, in 1737. He was taught the rudiments of his art by his stepfather, Peter Pelham, a portrait painter and mezzotint engraver whom Mrs. Copley had married after her first husband's death. He began to draw at a very early age, and at sixteen had not only painted a clever portrait, but had engraved a print from it.

The first picture he exhibited at the Royal Academy was of his half-brother, Henry Pelham, as "The Boy with the Squirrel", and was exhibited anonymously; but it was so much admired that Copley was advised to come to England, and he left America in 1774. He stayed for a while in England, then went on to Parma and Rome, became an Associate of the Royal Academy in 1776 and a Royal Academician in 1779.

Some of Copley's best portraits are in the Royal Collections, including one of three of the daughters of George III. He was the father of Lord Lyndhurst (1779-1863), who became Lord Chancellor. He resided in George Street, Hanover Square, where he died in 1815, and was buried in Croydon Church. His best known work is the celebrated "Death of Chatham".

PLATE LXXIII. The Sitwell Family. In the collection of Captain Osbert Sitwell. *Size of original:* 63 by 72 inches.

This notable group was painted in 1787. It is interesting to record that Sargent based the grouping of a picture of the present Sitwell family, which now hangs near it, on this work.

FRANCIS WHEATLEY

This very able painter was the son of a tailor in London, and was born in 1747. He received his first tuition at Shipley's Drawing School, and later went on to the schools of the Academy. When quite young he obtained several prizes from the Society of Arts, and formed a friendship with Mortimer, assisting that artist in painting a ceiling at Brocket Hall for Lord Melbourne. Later, he went to Dublin where he obtained many commissions and executed a number of portraits. In 1781 he returned to London where he was commissioned by Boydell to contribute twelve pictures to the Shakespeare Gallery. He also painted a picture of the Gordon Riots, which was engraved by Heath and was very popular, and contributed to Macklin's Poets' Gallery. He first exhibited at the Royal Academy in 1771, became an Associate in 1790, and a Royal Academician in 1791. In the last few years of his life he was tortured by gout, and died in 1801.

PLATE LXXIV. A Family Group. In the collection of Ronald Tree, Esq. *Size of original:* 25 by 30 inches.

This group was at one time supposed to represent members of the family of George III, but it is now certain that there is no evidence for this attribution. It remains, however, a charming example of Wheatley's art.

PLATE LXXV. Gingerbread. In the collection of Sir Alfred Beit, Bart. *Size of original:* 14 by 11 inches.

This is one of the original paintings for the famous series known as the "Cries of London". Other examples are in different collections.

The scene is a London street. There is a church, probably St. Martin's-in-the-Fields, in the background, and on the left are the columns of what would appear to be the entrance to another church.

PLATE LXXVI. A Pedlar at a Cottage Door. In the collection of The Lord Camrose. *Size of original:* 26 by 20 inches.

A delightful *genre* painting of a type in which Wheatley was one of the chief innovators.

PLATES LXXVII and LXXVIII. MAIDENHOOD, COURTSHIP, MARRIAGE AND MARRIED LIFE. In the collection of THE VISCOUNT BEARSTED. *Size of originals:* Each 31½ by 26½ inches.

These four pictures represent the story of a country girl in four scenes. In the first, "MAIDEN-HOOD", we see the girl with her mother, and the old lady is giving her sound advice. The girl has a basket in her hand, and is evidently just going out to do some shopping. In "COURTSHIP" we see the happy couple standing together in a room, clasping hands, while in "MARRIAGE" they are approaching the door of the church, with the old mother behind, and a group of spectators watching them. In "MARRIED LIFE" we see them seated together, close to one another, and two small children are at the husband's knee, while the wife, whom he clasps with one arm, is busy with her sewing.

HENRY WALTON

Walton was an English subject and portrait painter, born, it is said, in 1746. He died in 1813. He was a member of the Society of Artists, with which body he exhibited, as also he did with the Academy between the years 1771 and 1779.

PLATE LXXIX. A YOUNG GIRL BUYING A LOVE SONG. In the collection of THE LORD MILD-MAY. *Size of original:* 37 by 29 inches.

A beautiful little painting, representing a girl purchasing a love song from a street vendor of ballads.

PLATE LXXX. THE CHERRY SELLER. In the collection of CAPTAIN OSBERT SITWELL. *Size of original:* 30 by 25 inches.

Another street scene, in which a fashionable lady is buying cherries from an itinerant vendor, while her children cluster round the barrow.

BENJAMIN MARSHALL

Benjamin Marshall was an English animal painter, who was born in 1767 and died in 1835. We know nothing of his parentage or of his career, save that he worked in London for a while, and also probably at Newmarket. He was a contributor to the *Sporting Magazine*, and ex-hibited at the Royal Academy between 1800 and 1819, generally portraits of race-horses and their owners. His work was for a long while ignored. Recently, however, it has come into great repute, and his excellent pictures of horses, second perhaps only to those of Stubbs, are in great demand.

PLATE LXXXI. THOMAS OLDAKER ON HIS BROWN MARE "PICKLE". In the collection of THE LORD WOOLAVINGTON. *Size of original:* 39¾ by 51½ inches.

Oldaker was the huntsman of the Berkeley Hounds, and is represented seated on his brown mare "Pickle". Nearby are two of his hounds, and two others are seen in the distance. The mare is exquisitely painted.

PLATE LXXXII. MR. POWLETT AND HIS HOUNDS. In the collection of THE LORD WOOLAVING-TON. *Size of original:* 39¾ by 50 inches.

Mr. Powlett is seen surrounded by his hounds, with another huntsman riding up behind him, and a whipper-in in the act of mounting his horse.

PLATE LXXXIII. A YOUNG LADY WALKING IN A LANDSCAPE WITH A DOG. In the collection of F. C. GRAHAM MENZIES, Esq. *Size of original:* 37⅝ by 27¾ inches.

A charming composition, somewhat in the manner of some of Reynolds' portraits. The young lady wears a most elaborate turban.

CHARLES ROBERT LESLIE

Leslie was an Englishman born in London in 1794, of American parents. In 1808 he was apprenticed to a firm of publishers in Philadelphia, but, anxious to become an artist, he sailed for England in 1811, where he at once entered the school of the Royal Academy and obtained two silver medals. He came under the influence of Benjamin West, who was specially interested in him on account of his American parentage, and he exhibited at the Royal Academy between the years 1813 and 1839. He visited the Continent in 1817, in 1821 became an Associate of the Royal Academy, and in 1826 a full Academician. In 1833 he was induced to go back to America in order to become drawing master at the Military Academy at West Point, but was only there for one year, and returned to London. From 1847 to 1852 he was Professor of Painting at the Royal Academy, and published his lectures as a handbook for young painters, and, a little later, his Memoirs of Constable. He was summoned to Windsor in 1838 to paint the picture of the Queen receiving the Sacrament at her Coronation. He died in London in 1859.

PLATE LXXXIV. HOLLAND HOUSE LIBRARY. In the collection of THE EARL GREY. *Size of original:* 22¼ by 29 inches.

A delightful view of the long library at Holland House, full of books and pictures. In the foreground, grouped around a fine French table, are Lord and Lady Holland with their librarian and their secretary, all in black. The perspective in this picture is particularly expert.

HENRY AND WILLIAM BARRAUD

These two brothers were descended from an interesting family who came over to England from France at the time of the Revocation of the Edict of Nantes. The original ancestor settled himself as a clockmaker, and later became a well-known chronometer-maker in Cornhill. The father of the painters held an appointment in the Customs. We do not know who was their mother, but her father was stated to have been a miniature painter, and it was probably from him that both artists derived their artistic knowledge.

William, born in 1810, studied for a considerable time under Abraham Cooper, R.A., and acquired great skill in drawing dogs, horses and other animals. Henry, the younger brother, was born in 1812. Both brothers executed subject pictures, sometimes in conjunction with one another. Henry was responsible for a very popular picture, called "We Praise Thee, O God!" which depicted three choir-boys in their surplices. He also painted "The London Season", a scene in Hyde Park, and also a view of Lord's Cricket Ground. Both brothers exhibited at the Royal Academy. William died in 1850 and Henry in 1874.

PLATE LXXXV. THE DUCHESS OF KENT AND HER DAUGHTER, AFTERWARDS QUEEN VICTORIA. In the collection of MRS. F. C. GRAHAM MENZIES. *Size of original:* 36 by 50 inches.

The mother and her daughter, both in riding-habits, tall silk hats and veils, are riding in the park before Claremont. The young Princess is slightly behind her mother, while a dog is gambolling in front of them. The picture is signed "W. and H. Barraud, 1837", and is particularly interesting since it represents Princess Victoria in the very year in which she came to the throne.

ERRATA

PLATE XXIX. From information supplied by the family after going to press, it now transpires that the figure described as Mr. Clavey in the description on page 12 is in reality Mr. Bettesworth, Mrs. Clavey's brother, while that described as Richard Bettesworth is Charles Clavey, her husband.

PLATES LIX and LXVI. The originals are in the possession of The Hon. Mrs. Ionides.

PLATE II

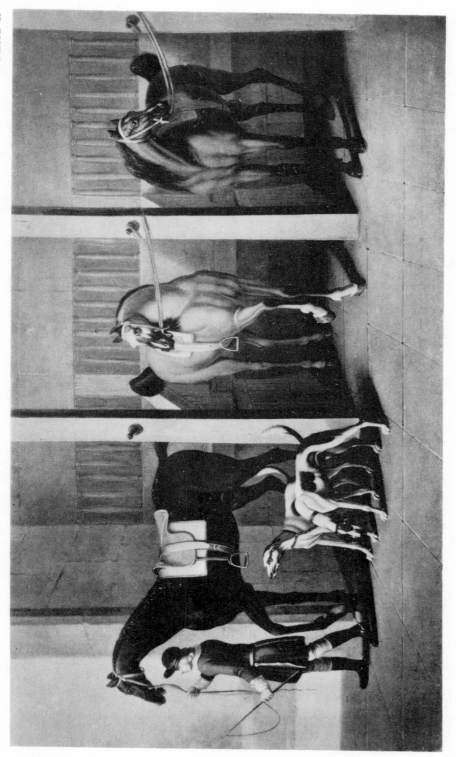

FAMOUS HUNTERS BELONGING TO H.R.H. THE DUKE OF YORK

Collection of H.R.H. The Duke of York

James Seymour

PLATE III

SIR ROBERT FAGGE AND THE GIPSY

James Seymour *Collection of The Lord Hylton*

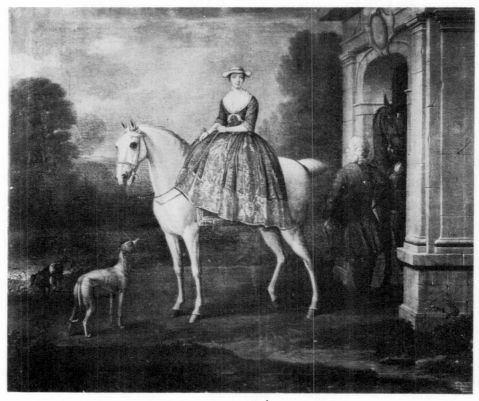

MRS. J. WARDE (NÉE BRISTOW)

John Wootton *Collection of Captain J. R. O'Brien Warde*

PLATE IV

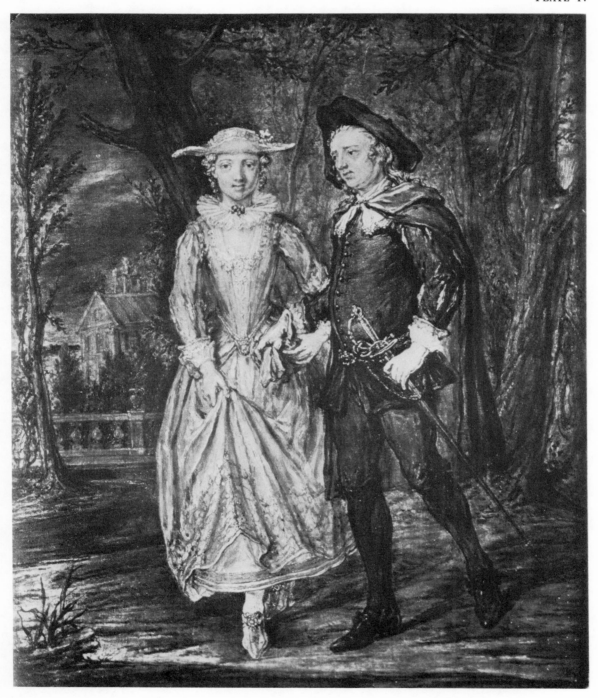

A LADY AND A GENTLEMAN WALKING IN A PARK

John Marcellus Laroon *Collection of Dr. Tancred Borenius*

PLATE V

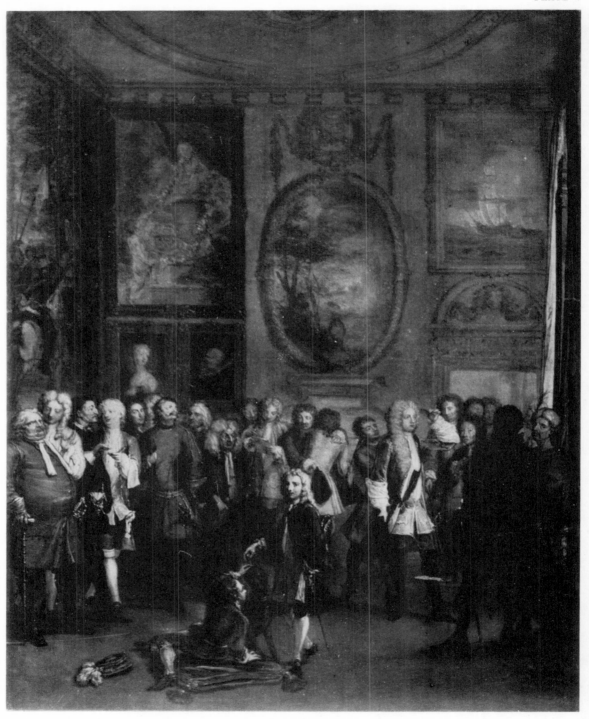

THE DUKE OF BUCKINGHAM'S LEVÉE

John Marcellus Laroon

Collection of Samuel Howard Whitbread, Esq.

PLATE VI

THE GREEN ROOM, DRURY LANE

Collection of *The Lord Glenconner*

Joseph Highmore

PLATE VII

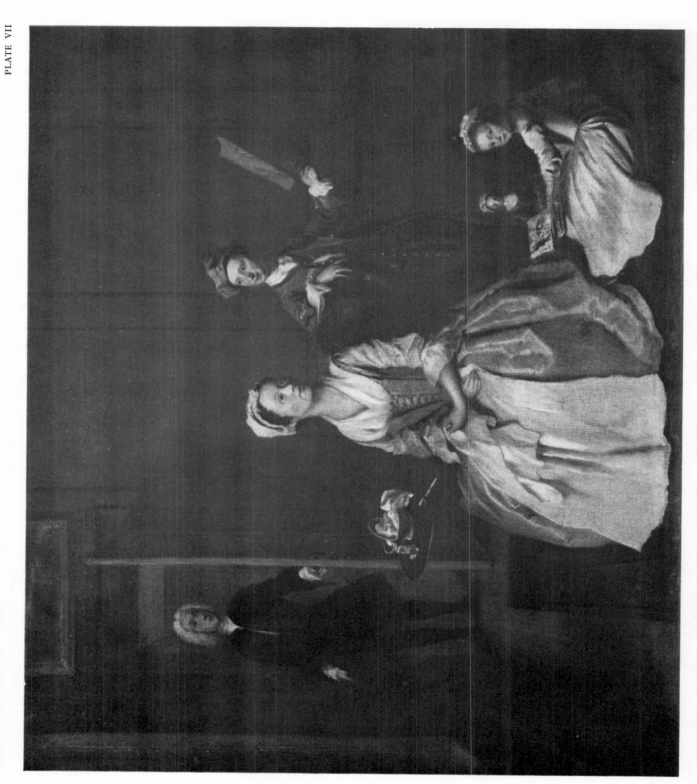

Joseph Highmore

A FAMILY GROUP

Collection of the Earl of Plymouth

PLATE VIII

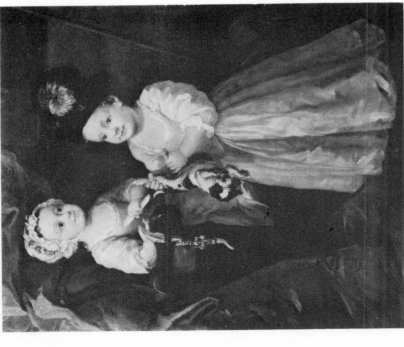

LORD GREY AND LADY MARY GREY AS CHILDREN

William Hogarth Collection of Leonard Gow, Esq.

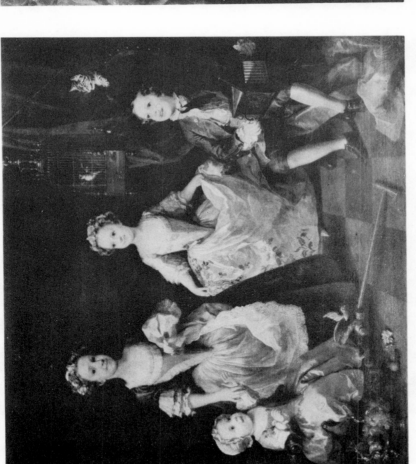

THE GRAHAM FAMILY

William Hogarth Collection of The Earl of Normanton

PLATE IX

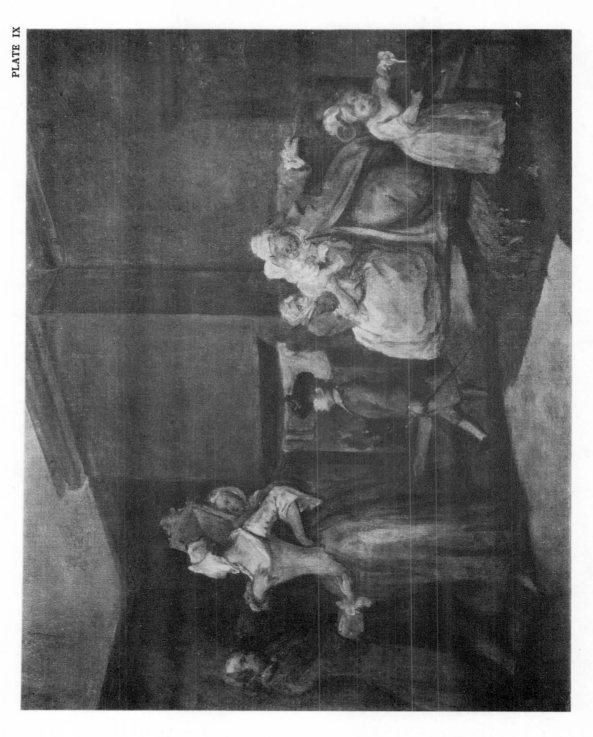

THE STAYMAKER

William Hogarth

PLATE X

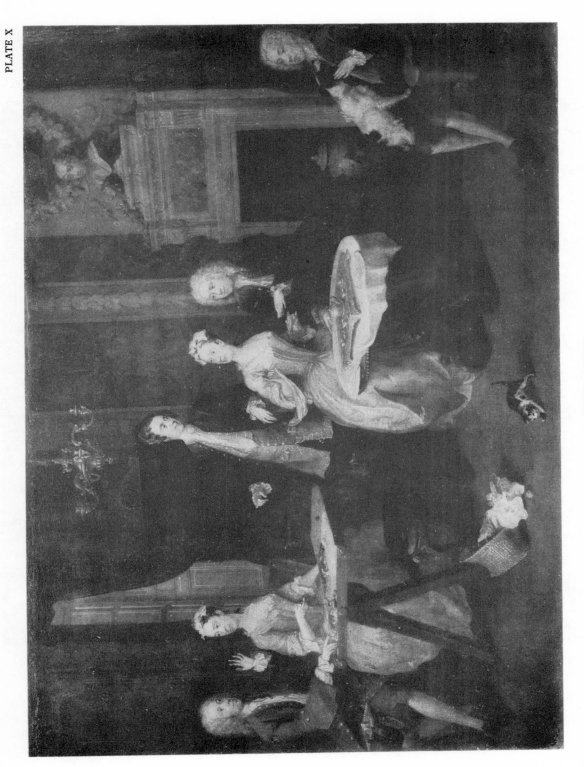

A FAMILY PARTY

William Hogarth

Collection of Sir Herbert Cook, Bart.

PLATE XI

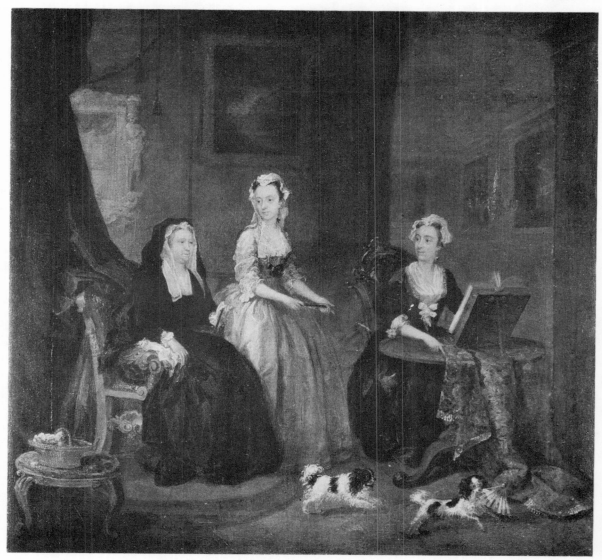

THE BROKEN FAN

William Hogarth

Collection of The Lord Northbrook

PLATE XII

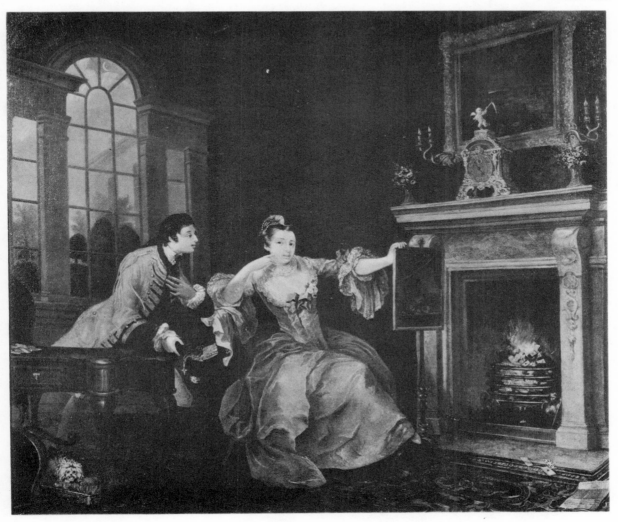

THE LADY'S LAST STAKE

William Hogarth

Collection of The Duke of Richmond and Gordon

PLATE XIII

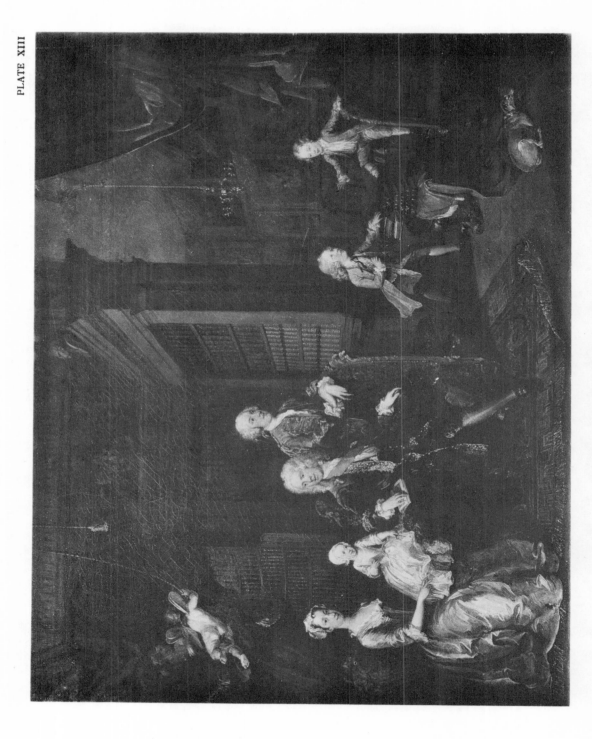

THE CHOLMONDELEY FAMILY

William Hogarth

Collection of The Marquess of Cholmondeley

PLATE XIV

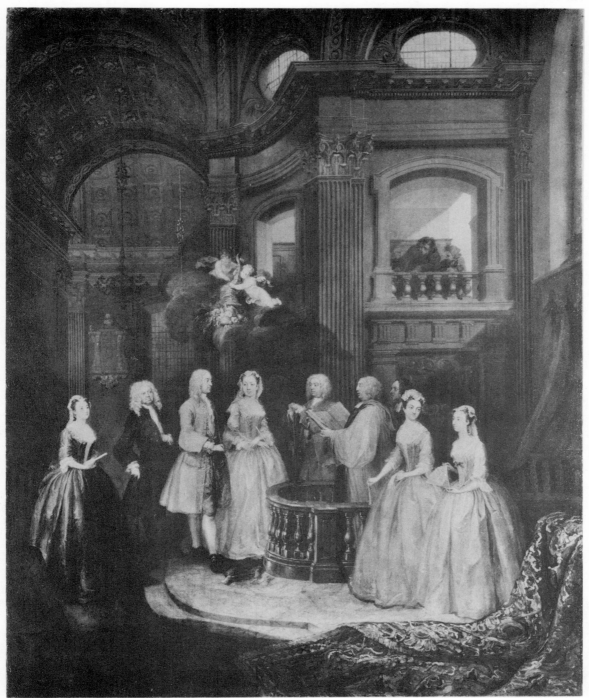

THE WEDDING OF MR. STEPHEN BECKINGHAM AND MISS MARY COX (OF KIDDERMINSTER)

William Hogarth

Collection of James Carstairs, Esq.

PLATE XV

STUDY FOR THE MASKED BALL AT THE WANSTEAD ASSEMBLY

Collection of The Borough of Camberwell, South London Art Gallery

William Hogarth

PLATE XVI

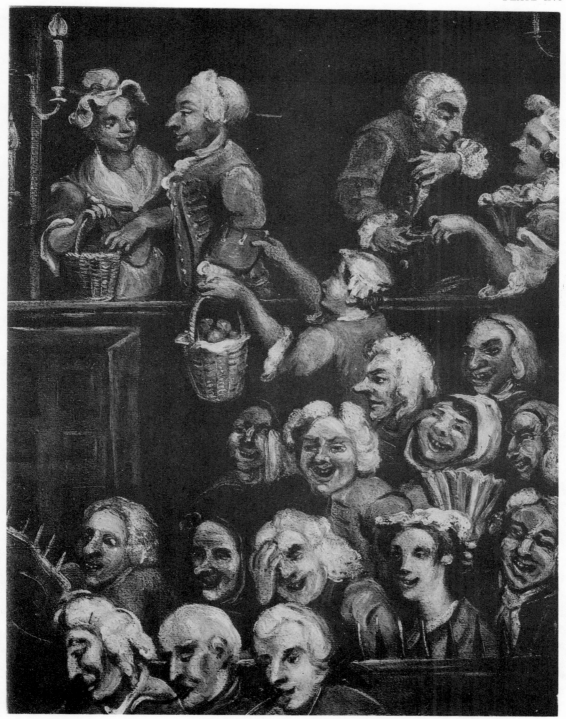

THE LAUGHING AUDIENCE

William Hogarth *Collection of L. C. Lewis, Esq.*

PLATE XVII

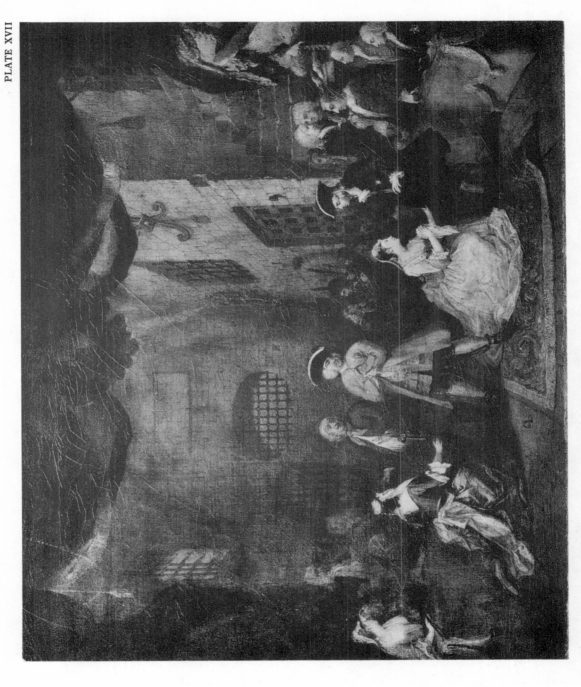

SCENE FROM "THE BEGGAR'S OPERA," BY JOHN GAY

William Hogarth

Collection of The Duke of Leeds

PLATE XVIII

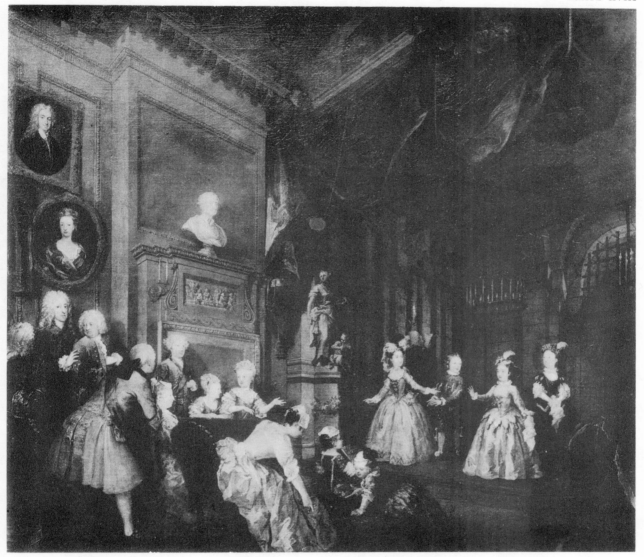

SCENE FROM "THE INDIAN EMPEROR"

William Hogarth *Collection of Mary, Countess of Ilchester*

PLATE XIX

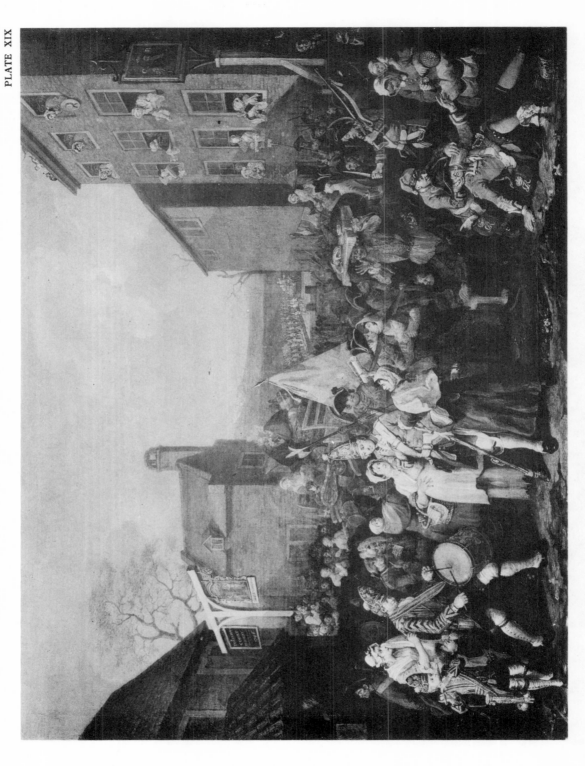

THE MARCH OF THE GUARDS TO FINCHLEY

Collection of The Governors of the Foundling Hospital

William Hogarth

PLATE XX

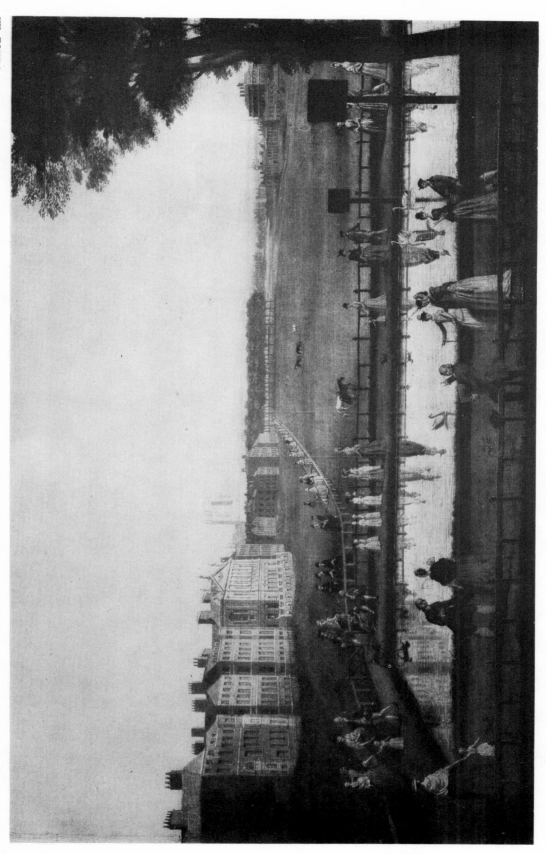

VIEW OF THE GREEN PARK, LONDON

Unknown Artist

Collection of *The Earl Spencer*

PLATE XXI

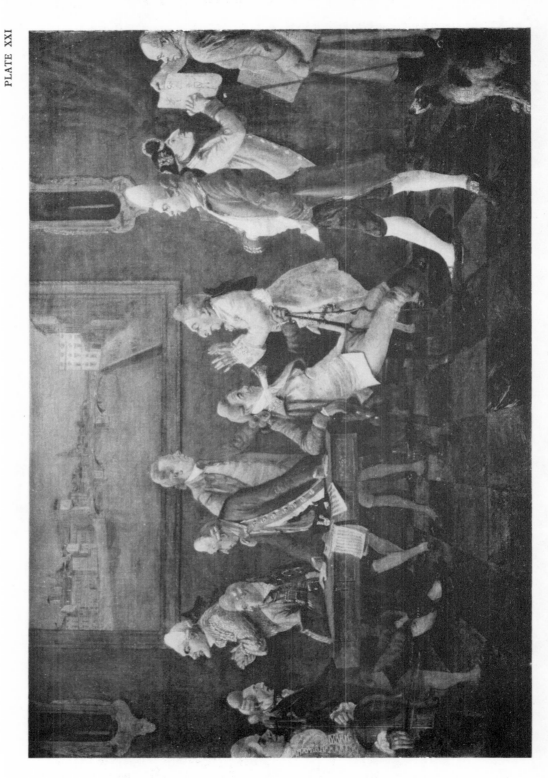

PLATE XXII

A MUSICAL PARTY

Collection of Captain E. G. Spencer-Churchill

Joseph Francis Nollekens

PLATE XXIII

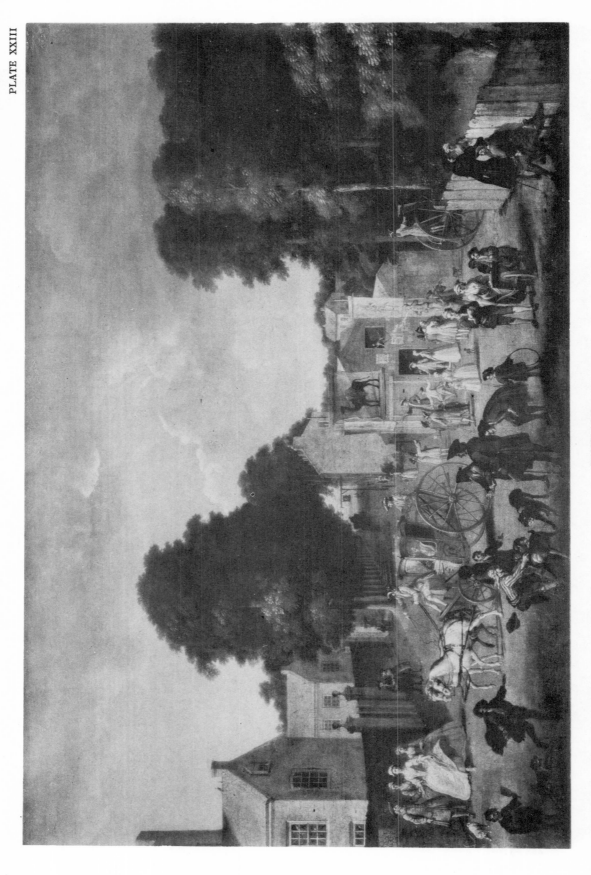

RANELAGH

Francis Hayman

Collection of Mary, Countess of Ilchester

PLATE XXIV

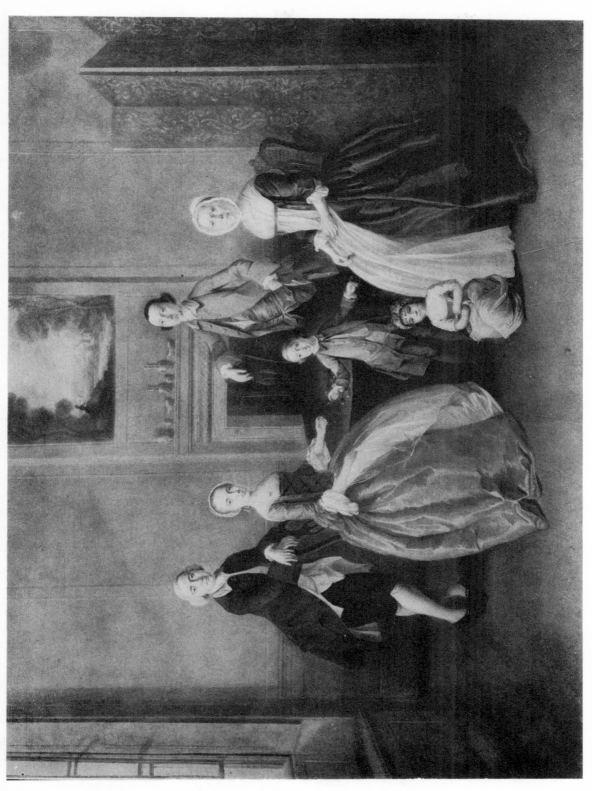

FAMILY GROUP

Francis Hayman

Collection of The Viscount Lee of Fareham

PLATE XXV

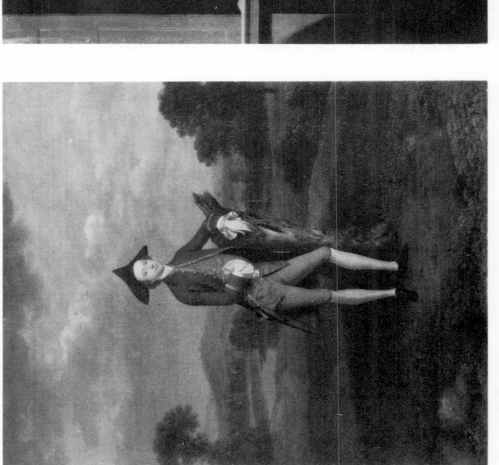

ONE OF THE SERGISON FAMILY
(OF CUCKFIELD)

Arthur Devis

Collection of Lady Brooke

ONE OF THE SERGISON FAMILY
(OF CUCKFIELD)

Arthur Devis

Collection of Lady Brooke

PLATE XXVI

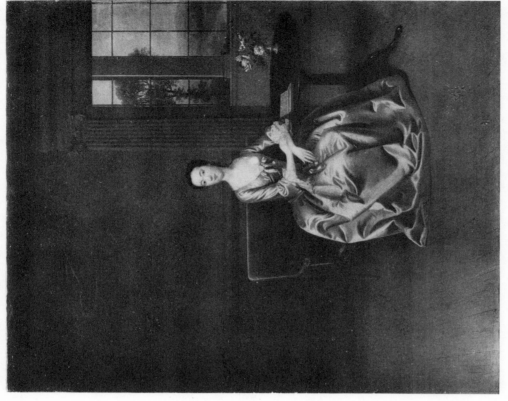

MISS SARAH WARDEN

Arthur Devis
Collection of Lady Brooke

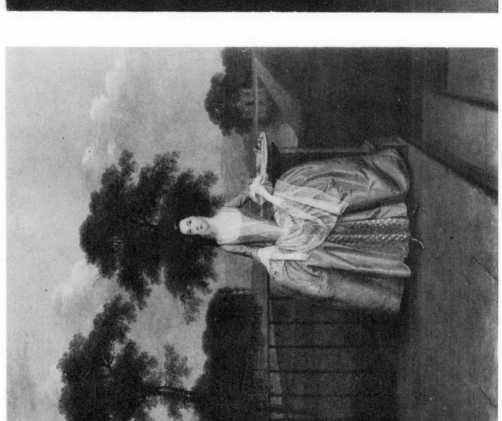

MISS MARY WARDEN

Arthur Devis
Collection of Lady Brooke

PLATE XXVII

TWO LITTLE MISS EDGARS

Arthur Devis

Collection of The Viscount Bearsted

MR. ORLEBAR

Collection of
The Viscountess Cowdray

Arthur Devis

PLATE XXVIII

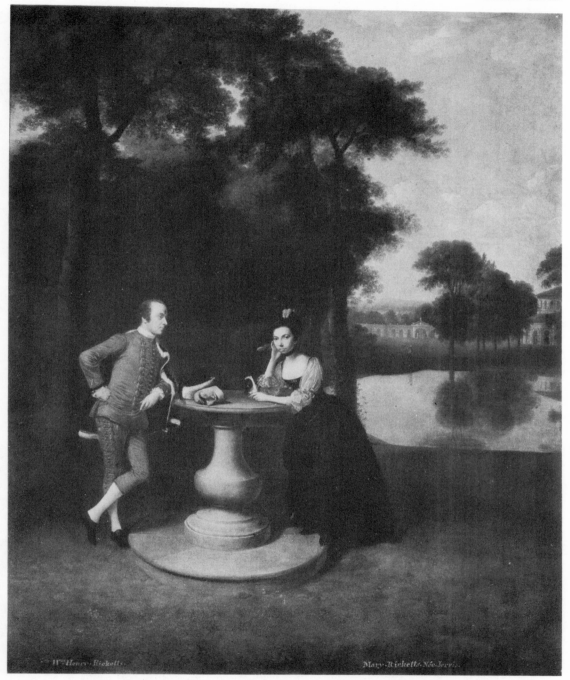

AN INCIDENT IN THE GROUNDS OF RANELAGH DURING A BAL MASQUÉ

Arthur Devis *Collection of Lieut.-Col. W. S. W. Parker-Jervis, D.S.O.*

PLATE XXIX

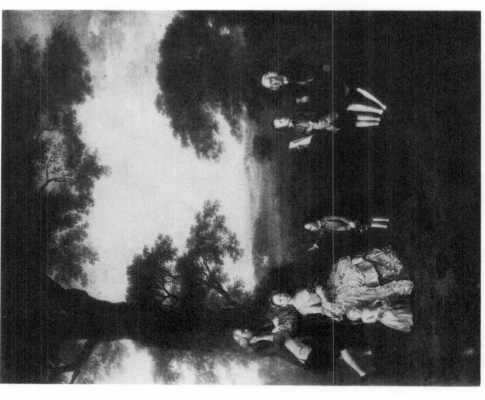

CHARLES CLAVEY WITH HIS WIFE, THREE CHILDREN AND
BROTHER-IN-LAW (RICHARD BETTESWORTH)

Arthur Devis Collection of H. E. Griffith, Esq.

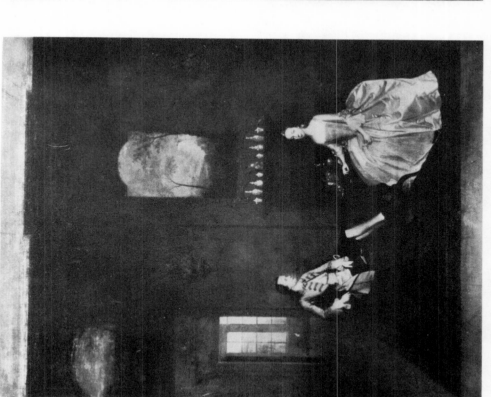

MR. AND MRS. RICHARD BULL OF NORTHCOURT

Arthur Devis Collection of Jesse Isidor Strauss, Esq.

PLATE XXX

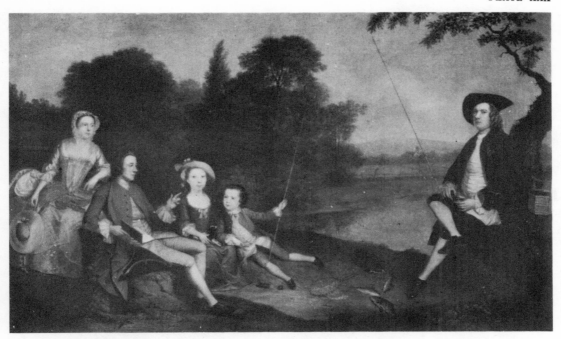

A FAMILY OF ANGLERS: THE SWAINE FAMILY OF LAVERINGTON HALL, IN THE ISLE OF ELY

Arthur Devis *Collection of Arthur N. Gilbey, Esq.*

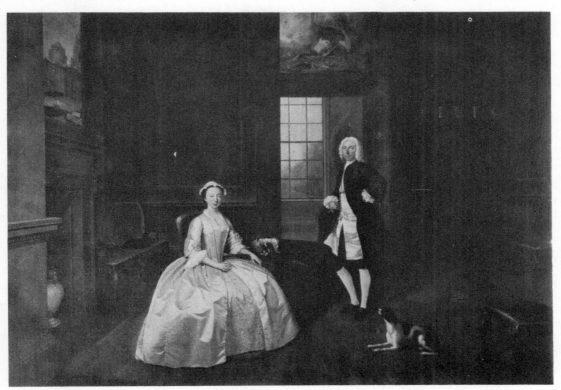

MR. WILLIAM ATHERTON AND HIS WIFE LUCY

Arthur Devis *Collection of The Lady Daresbury*

PLATE XXXI

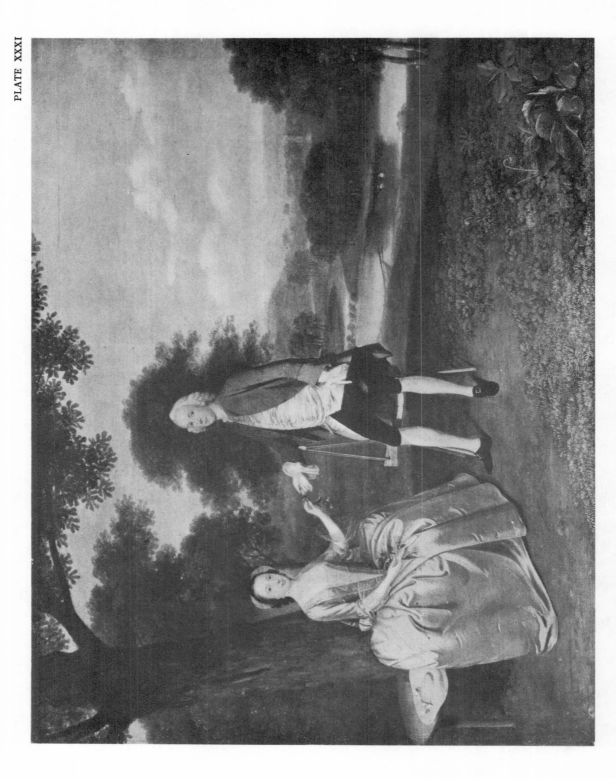

Arthur Devis

HORACE WALPOLE PRESENTING KITTY CLIVE WITH A PIECE OF HONEYSUCKLE

Collection of Lady Margaret Douglas

PLATE XXXII

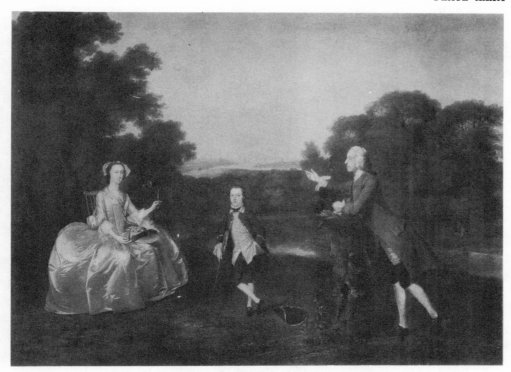

MR. AND MRS. VAN HARTHALS AND THEIR SON

Arthur Devis *Collection of The Viscount Bearsted*

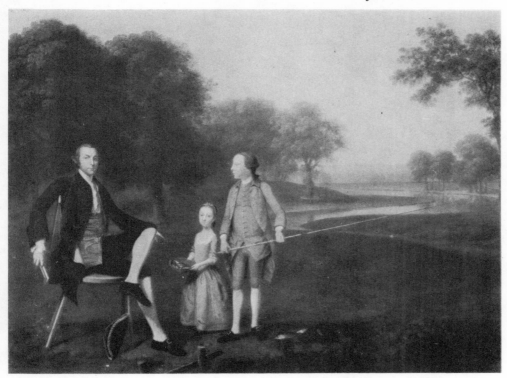

RICHARD MORETON, ESQ., OF TACKLEY

Arthur Devis *Collection of J. Haseltine Carstairs, Esq.*

PLATE XXXIII

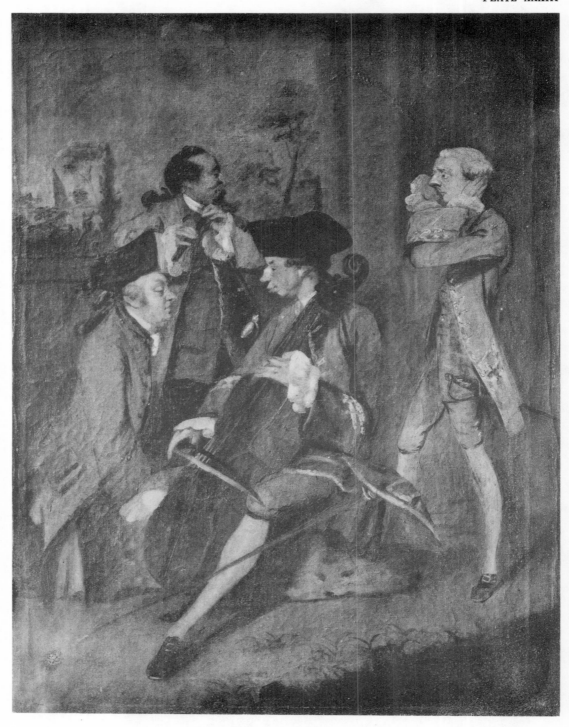

SOME OF THE ARTIST'S FRIENDS

Sir Joshua Reynolds

Collection of Julian Lousada, Esq.

PLATE XXXIV

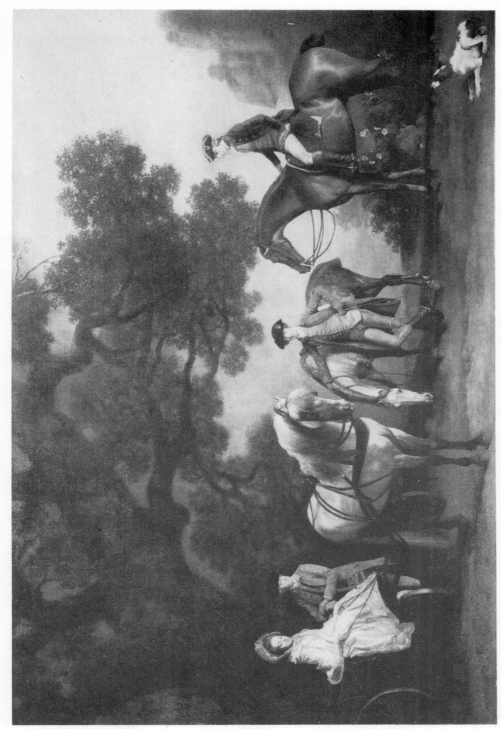

George Stubbs

LORD AND LADY MELBOURNE, WITH SIR RALPH MILBANKE AND MR. JOHN MILBANKE

Collection of The Lady Desborough

PLATE XXXV

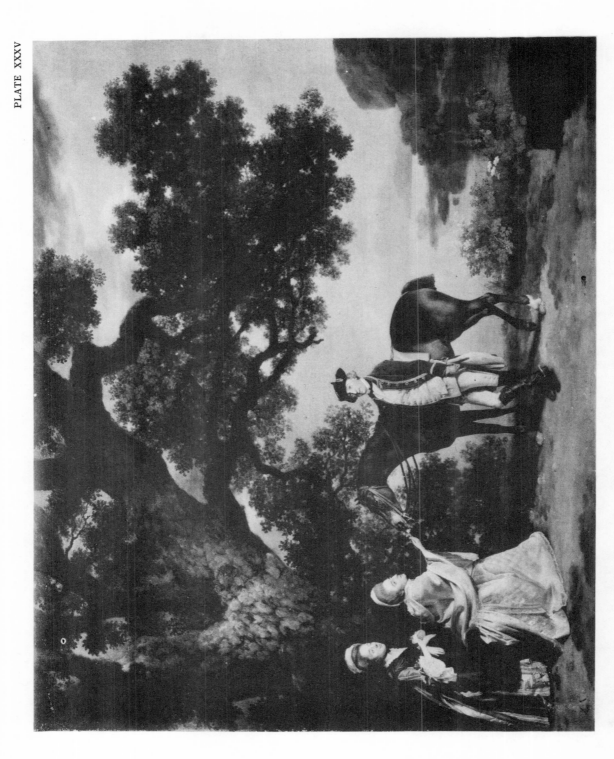

COLONEL POCKLINGTON AND FAMILY

Collection of Mrs. Charles Carstairs

George Stubbs

PLATE XXXVI

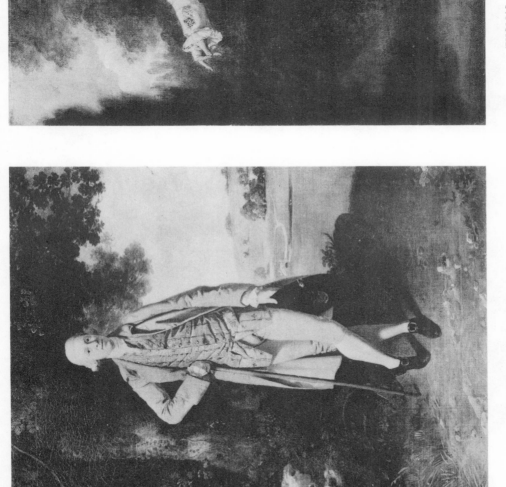

THOMAS KING AS LORD OGLEBY

Collection of The Hon. Evan Charteris

John Zoffany

PORTRAIT OF A MAN

Collection of Marshall Field, Esq.

John Zoffany

PLATE XXXVII

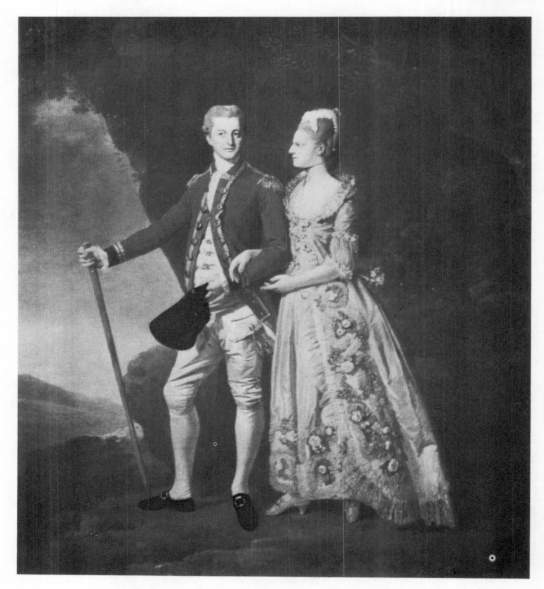

SAMUEL BLUNT OF HORSHAM AND WINIFRED HIS WIFE (NÉE SCAWEN)

John Zoffany *Collection of Arthur Scawen-Blunt, Esq.*

PLATE XXXVIII

GENTLEMEN COMMONERS OF CHRIST CHURCH, OXFORD

John Zoffany

Collection of Colonel Richard F. Roundell

PLATE XXXIX

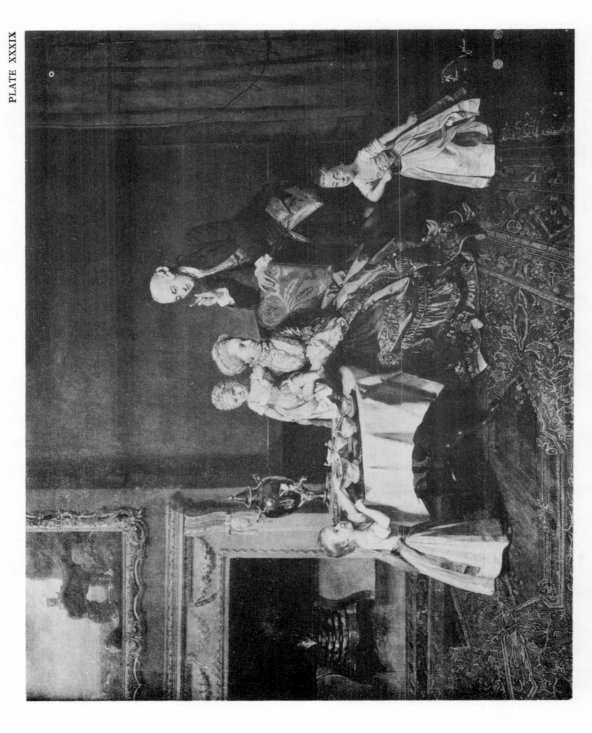

JOHN, FOURTEENTH LORD WILLOUGHBY DE BROKE, WITH HIS WIFE AND THEIR THREE CHILDREN

John Zoffany

Collection of The Lord Willoughby de Broke

PLATE XL

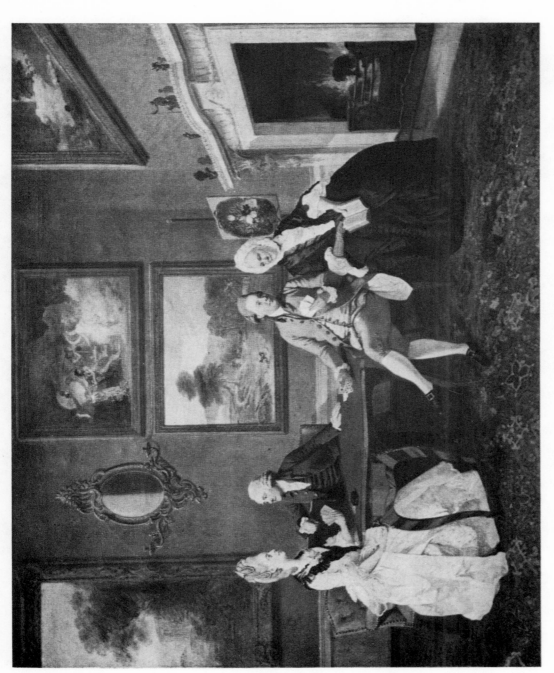

THE DUTTON FAMILY

Collection of Daniel H. Farr, Esq.

John Zoffany.

PLATE XLI

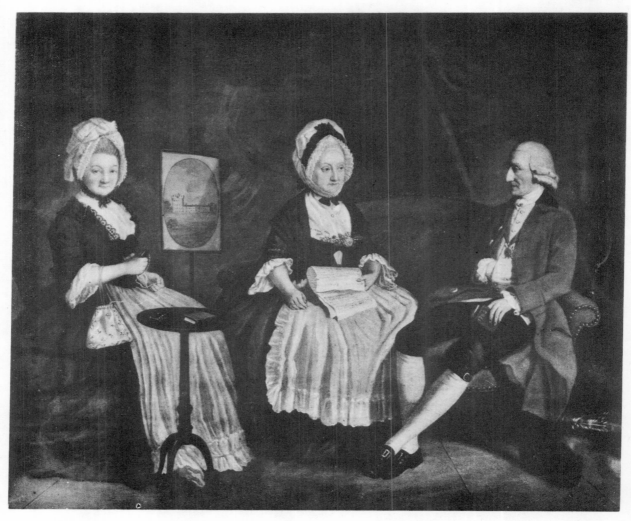

THE HONOURABLE CHARLES HOPE VERE WITH HIS SISTERS

John Zoffany

Collection of Sir Harry Verney, K.C.V.O.

PLATE XLII

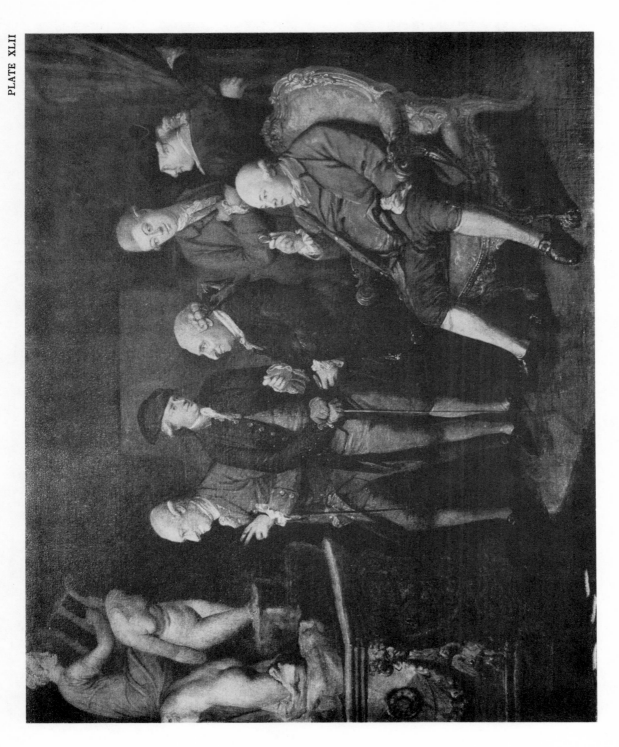

A GROUP OF CONNOISSEURS

Collection of The Lord O'Hagan

John Zoffany

PLATE XLIII

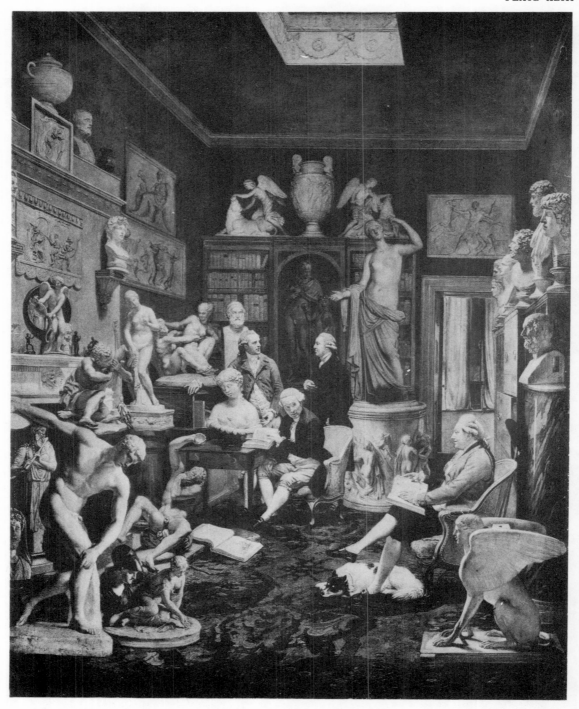

CHARLES TOWNELEY AND HIS FRIENDS IN HIS LIBRARY

John Zoffany

Collection of The Lord O'Hagan

PLATE XLIV

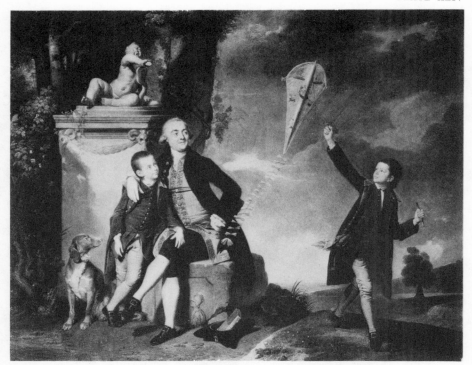

A MAN AND TWO BOYS, ONE WITH A KITE

Collection of

John Zoffany *Sidney Herbert, Esq., and Michael Herbert Esq.*

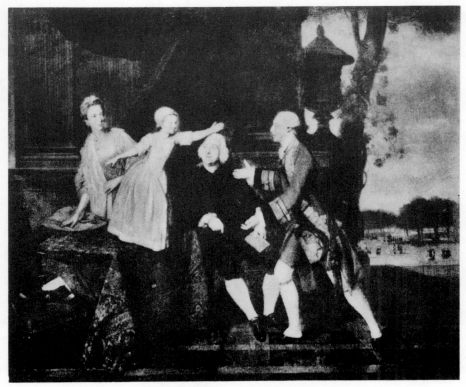

LORD NUGENT AND HIS FAMILY
WITH THE HORSE GUARDS' PARADE IN THE DISTANCE

John Zoffany *Collection of Sir George Guy Bulwer Nugent, Bart.*

PLATE XLV

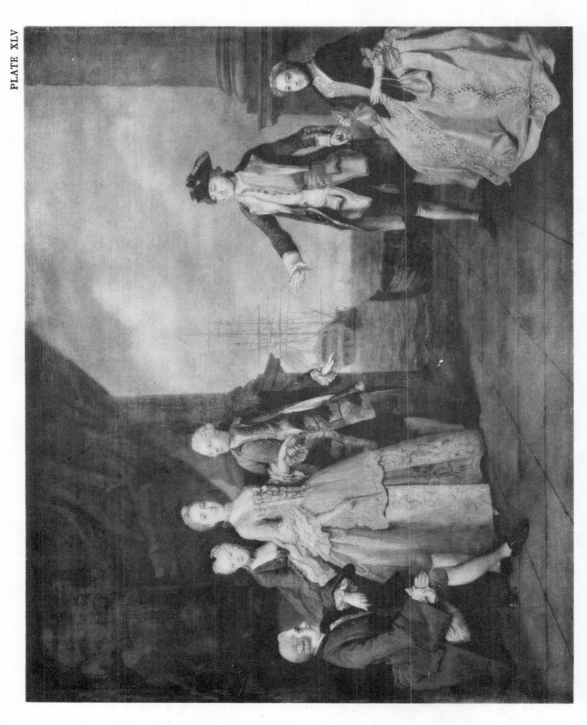

CAPTAIN JOHN AUGUSTUS HERVEY TAKING LEAVE OF HIS FAMILY ON HIS APPOINTMENT TO THE COMMAND OF A SHIP

John Zoffany

Collection of The Marquess of Bristol

PLATE XLVI

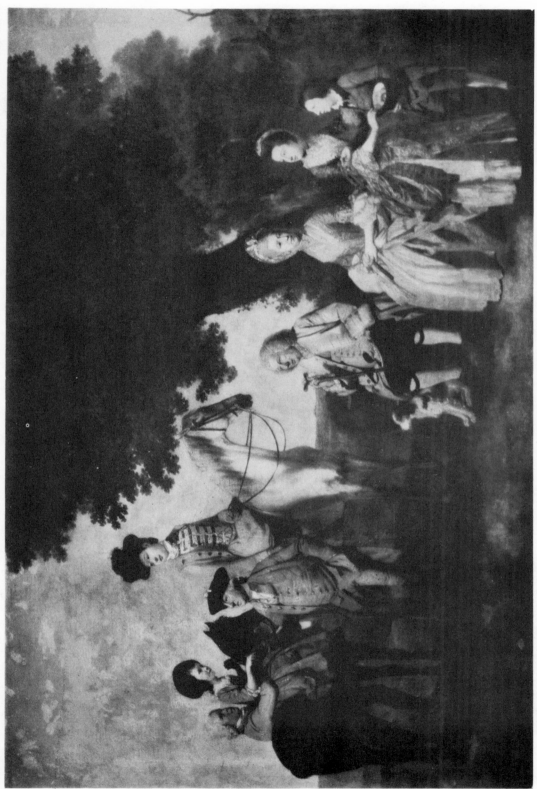

THE DRUMMOND FAMILY

John Zoffany

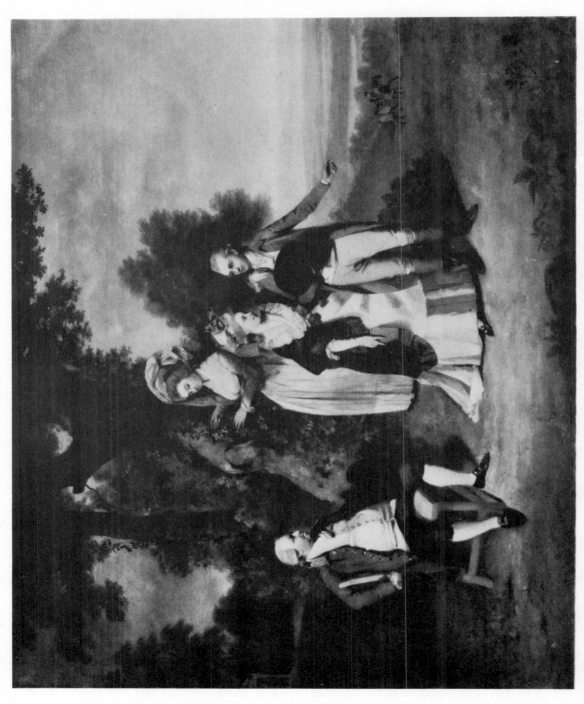

PLATE XLVII

THE GRAHAM FAMILY

John Zoffany

PLATE XLVIII

THREE CHILDREN BLOWING BUBBLES

John Zoffany

Collection of A. P. Cunliffe, Esq.

PLATE XLIX

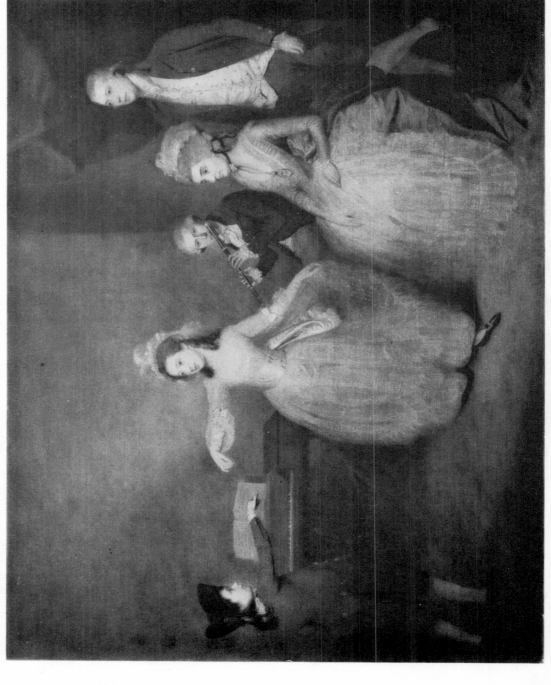

John Zoffany
A FAMILY PARTY. THE MINUET
Collection of The Corporation of Glasgow

PLATE L

GEORGE, THIRD EARL COWPER, COUNTESS COWPER AND THE GORE FAMILY

John Zoffany

Collection of The Lady Desborough

PLATE LI

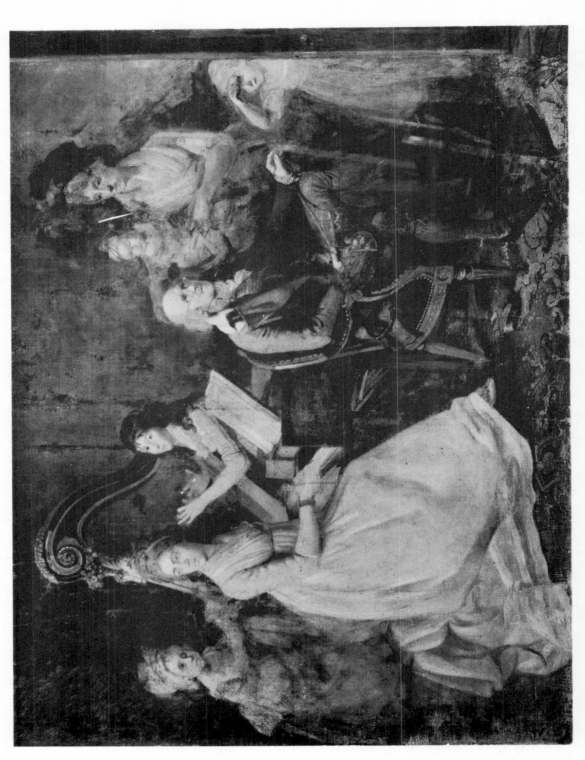

Collection of Mrs. O. Benwell

THE ARTIST, HIS WIFE, THEIR CHILDREN, AND A NURSE

John Zoffany

PLATE LII

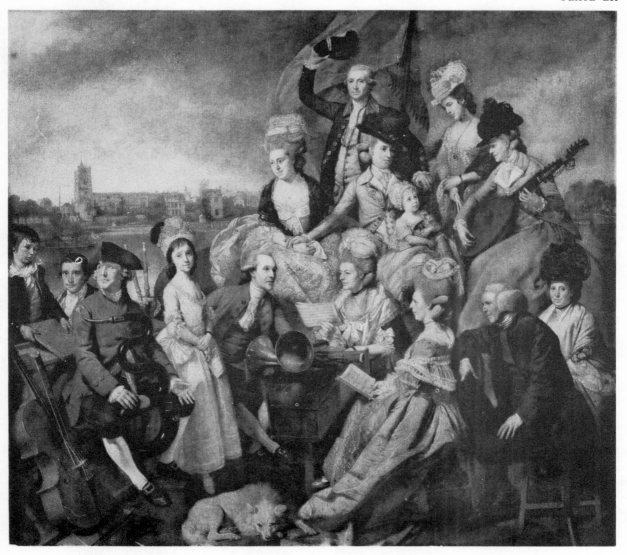

A MUSIC PARTY ON THE THAMES AT FULHAM

John Zoffany *Collection of Miss Olive Lloyd-Baker*

PLATE LIII

John Zoffany

THE FAMILY OF SIR WILLIAM YOUNG, BART.

Collection of Sir Philip Sassoon, Bart.

PLATE LIV

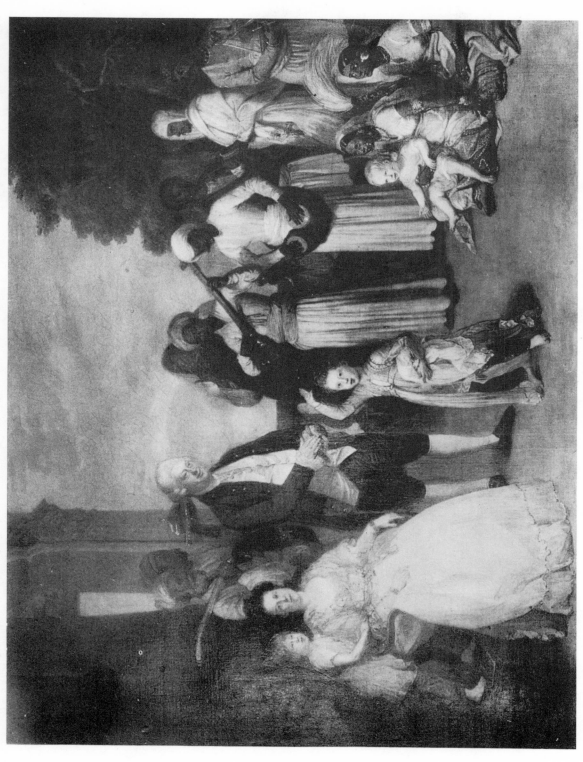

SIR ELIJAH AND LADY IMPEY AND THEIR FAMILY

John Zoffany

Collection of Edward Impey, Esq.

PLATE LV

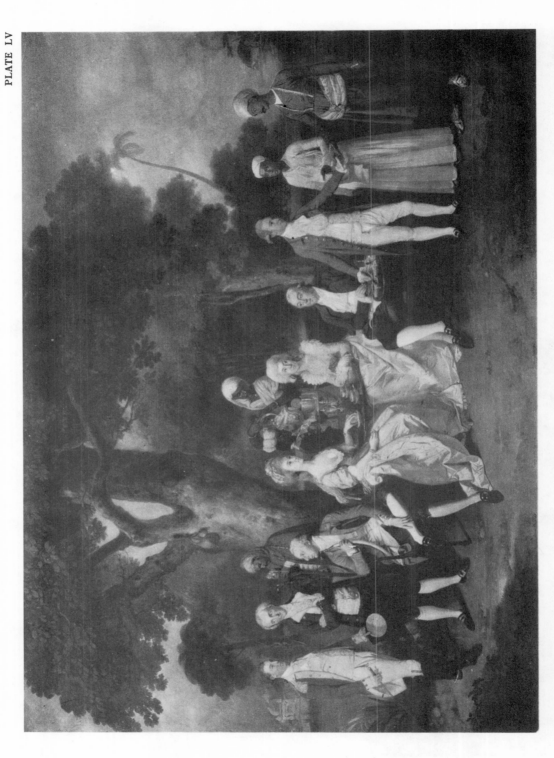

Collection of M. G. Dashwood, Esq.

THE AURIOL FAMILY

John Zoffany

PLATE LVI

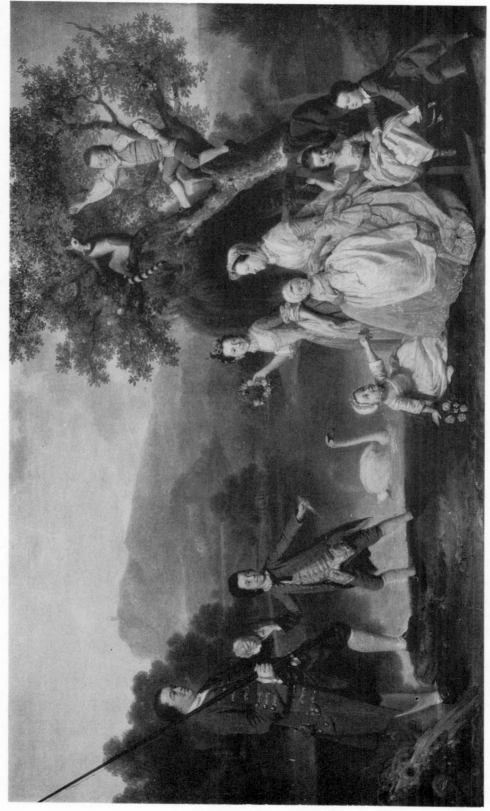

John Zoffany

JOHN, THIRD DUKE OF ATHOLL AND HIS FAMILY ON THE BANKS OF THE TAY AT DUNKELD

Collection of The Duke of Atholl

PLATE LVII

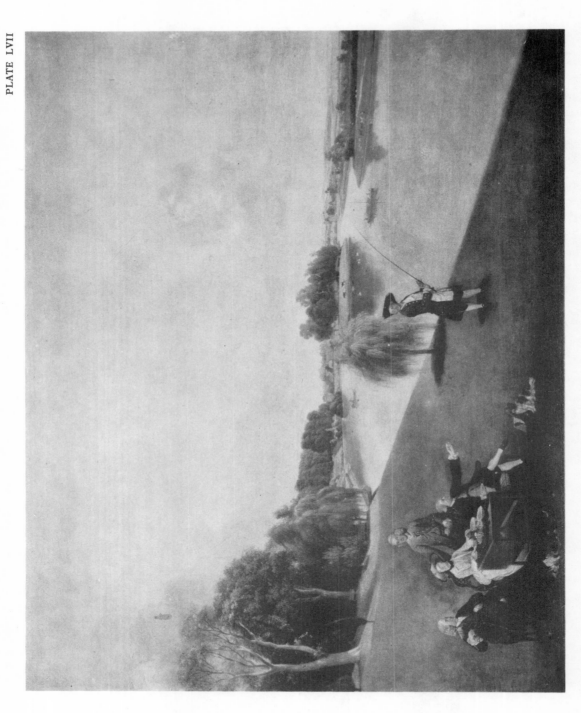

MR. AND MRS. GARRICK ENTERTAINING DR. JOHNSON TO TEA

John Zoffany

Collection of The Earl of Durham

PLATE LVIII

MR. AND MRS. GARRICK STANDING ON THE STEPS OF SHAKESPEARE'S TEMPLE AT HAMPTON

John Zoffany

Collection of The Earl of Durham

PLATE LIX

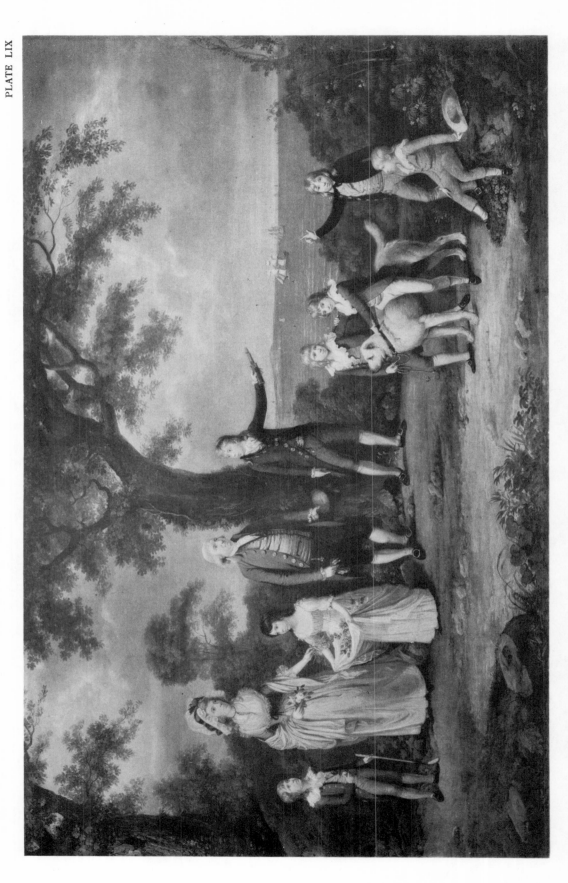

THE DRUMMOND FAMILY AT CADLAND

Collection of The Hon Mrs. Walter Levy

John Zoffany

PLATE LX

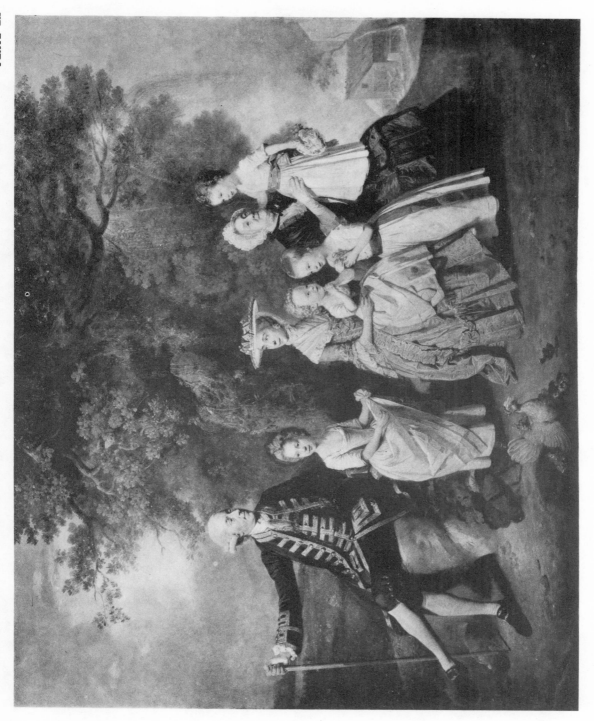

THE COLMORE FAMILY

John Zoffany

Collection of Sir Philip Sassoon. Bart.

PLATE LXI

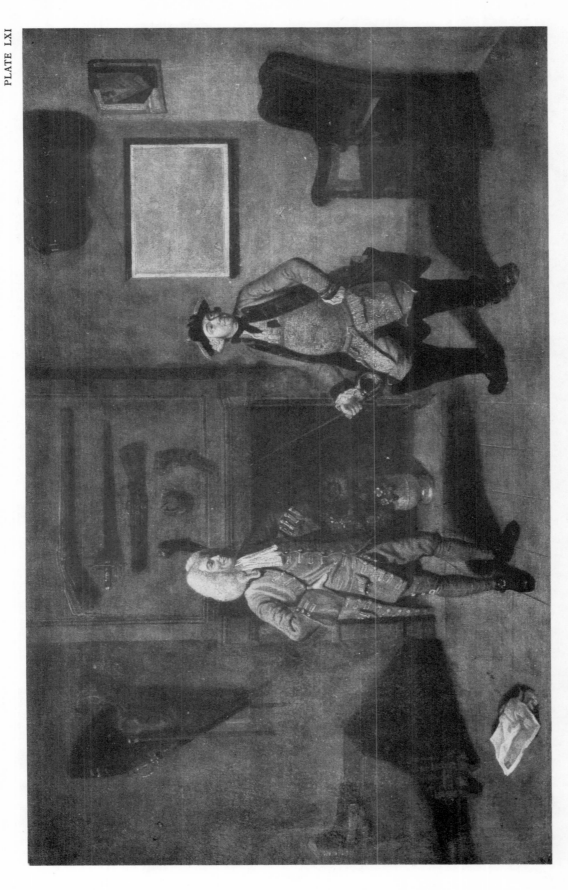

John Zoffany

SAMUEL FOOTE AS MAJOR STURGEON, AND HAYES AS SIR JACOB JOLLOP IN "THE MAYOR OF GARRATT"

Collection of Mrs. David Gubbay

PLATE LXII

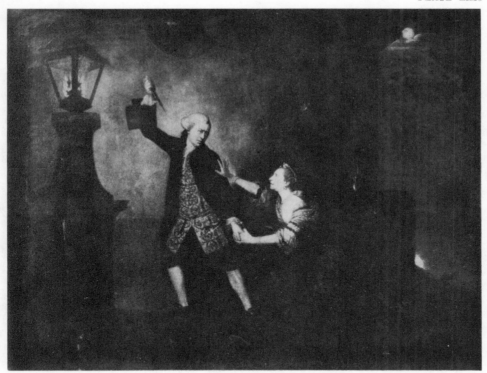

DAVID GARRICK AND MRS. CIBBER IN "VENICE PRESERVED"

John Zoffany *Collection of The Earl of Durham*

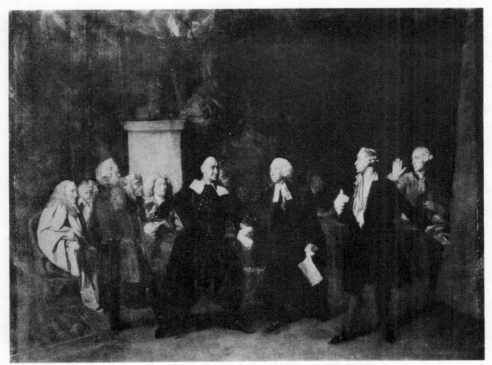

MACKLIN AS SHYLOCK

John Zoffany *Collection of The Marquess of Lansdowne*

PLATE LXIII

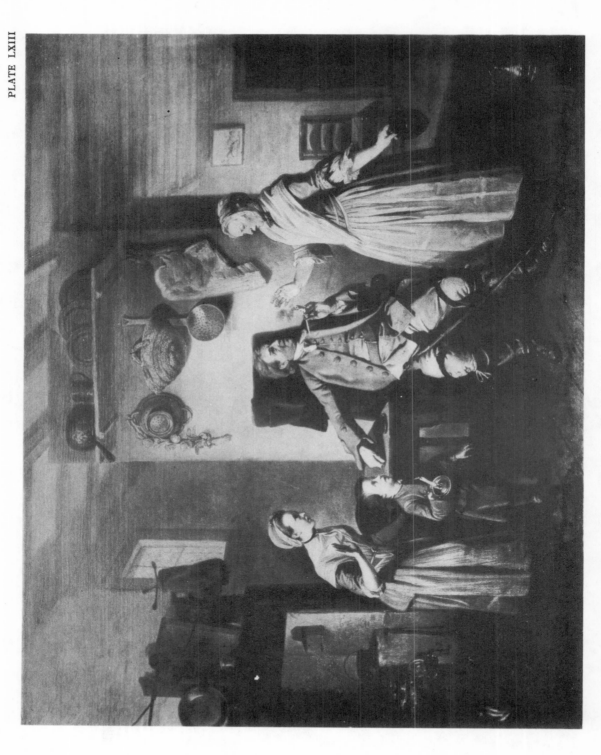

John Zoffany

DAVID GARRICK AND MRS. CIBBER IN " THE FARMER'S RETURN "

Collection of The Earl of Durham

PLATE LXIV

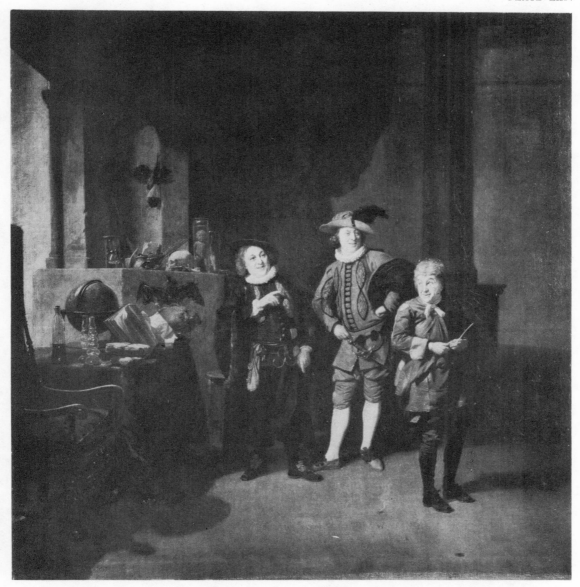

DAVID GARRICK AS ABEL DRUGGER

John Zoffany *Collection of The Hon. Geofrey Howard*

PLATE LXV

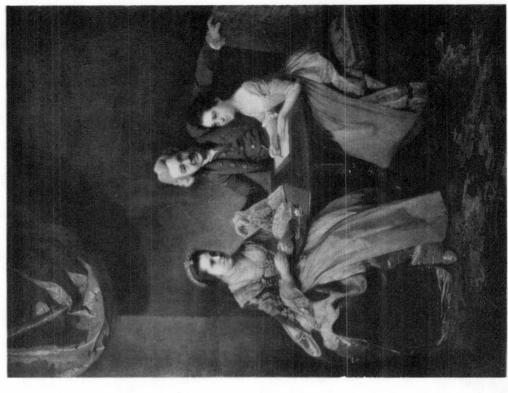

MR. AND MRS. PALMER AND THEIR DAUGHTER

John Zoffany Collection of The Hon. Frederick Wallop

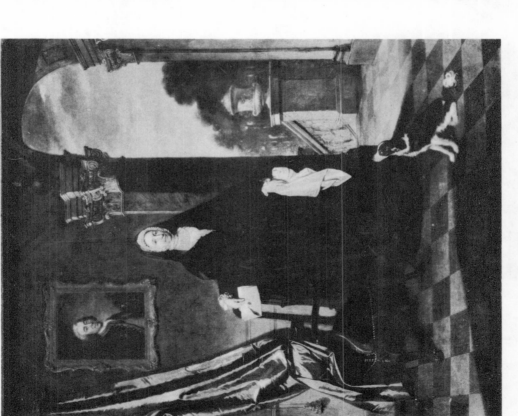

MRS. SALUSBURY Collection of The Marquess of Lansdowne

John Zoffany

PLATE LXVI

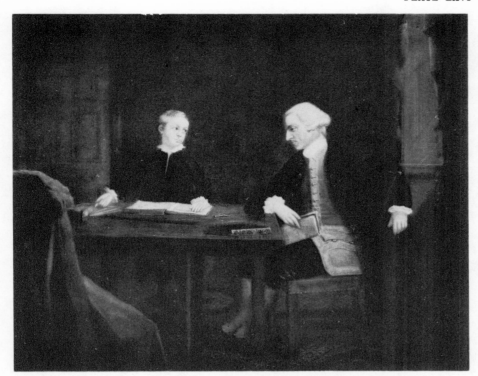

SAMUEL SMITH AND HIS SON, WILLIAM SMITH

John Zoffany *Collection of Frank Travers, Esq.*

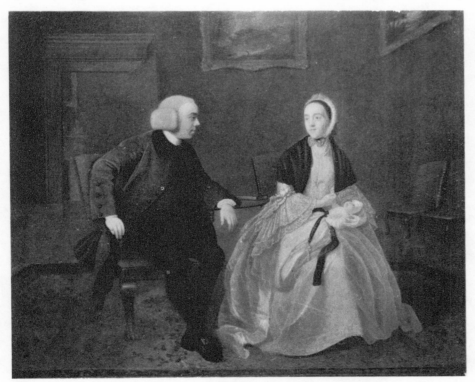

THE REVEREND EDWARD AND MRS. HUNLOKE

John Zoffany *Collection of The Hon. Mrs. Walter Levy*

PLATE LXVII

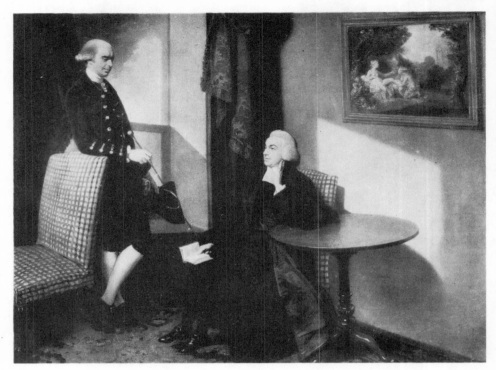

THE REV. JOHN COCKS AND JAMES COCKS

John Zoffany *Collection of The Hon. Esmond Harmsworth*

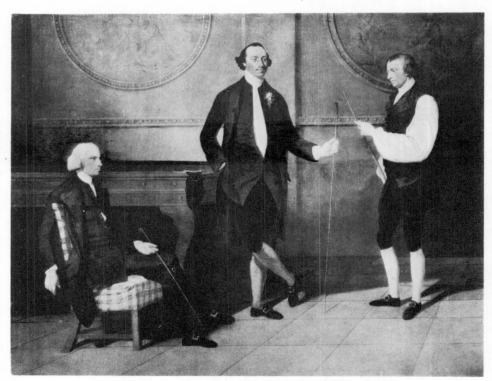

THE BOOTH FAMILY

John Hamilton Mortimer *Collection of The Viscount Bearsted*

PLATE LXVIII

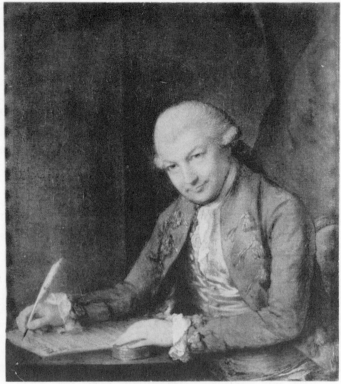

JOHANN CHRISTIAN BACH,
SON OF JOHN SEBASTIAN BACH

Thomas
Gainsborough

Collection of
The Dowager Lady Hillingdon

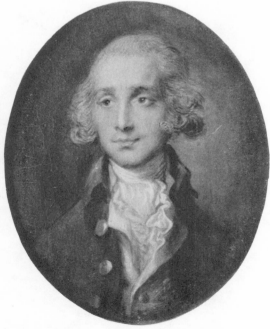

MEDALLION PORTRAIT OF A GENTLEMAN

Thomas
Gainsborough

Collection of
The Dowager Lady Hillingdon

MEDALLION PORTRAIT OF SIR J. BASSETT

Thomas
Gainsborough

Collection of
The Dowager Lady Hillingdon

PLATE LXIX

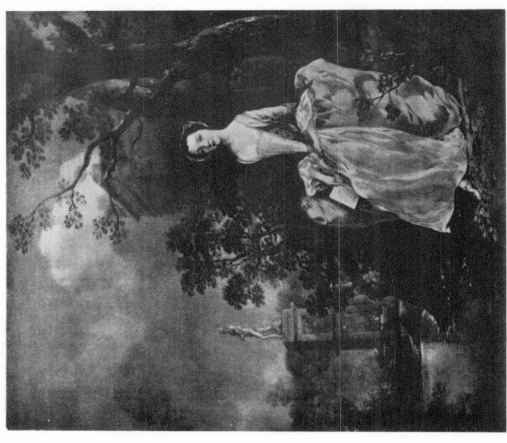

A YOUNG LADY SEATED IN A LANDSCAPE

Thomas Gainsborough

Collection of Sir Herbert Cook, Bart.

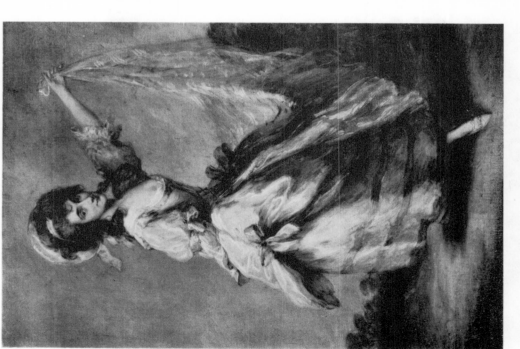

GIOVANNA BACCELLI, THE DANCER

Collection of
Sir Alfred Beit, Bart.

Thomas Gainsborough

PLATE LXX

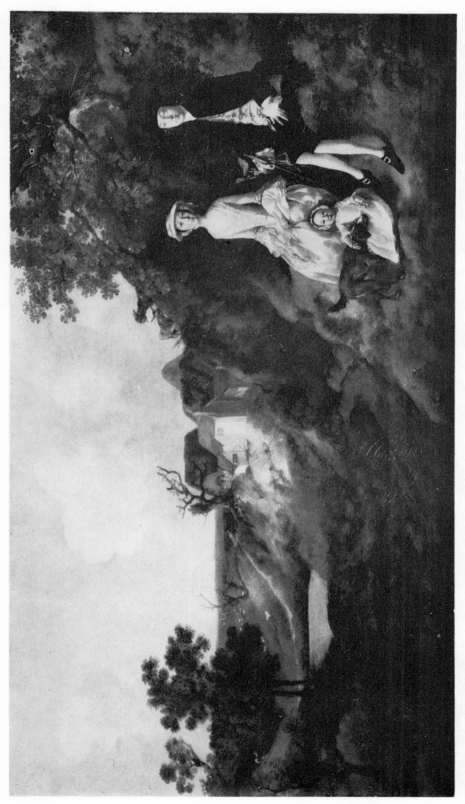

Thomas Gainsborough

MR. AND MRS. BROWN OF TRENT HALL

Collection of Sir Philip Sassoon, Bart.

PLATE LXXI

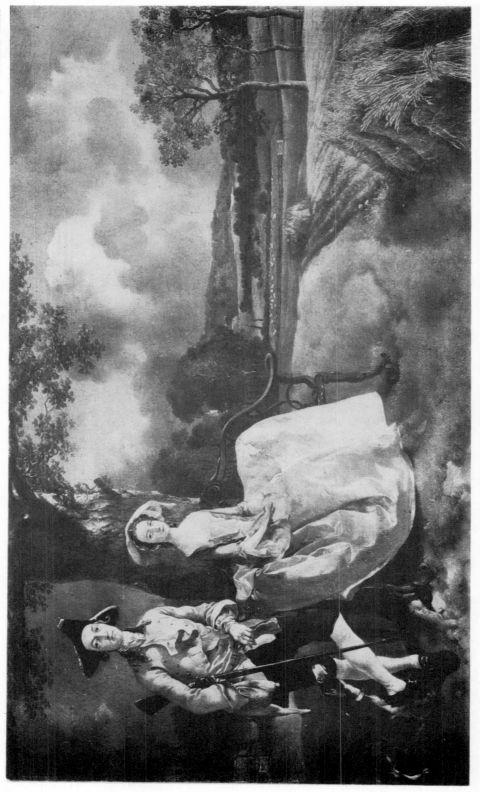

Thomas Gainsborough

ROBERT ANDREWS AND HIS WIFE

Collection of G. W. Andrews, Esq.

PLATE LXXII

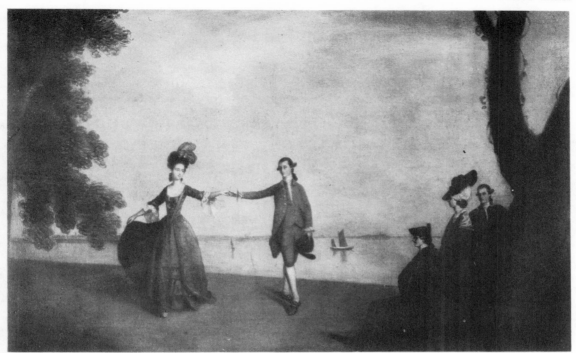

THE MINUET

Thomas Gainsborough *Collection of Lt.-Col. Giles H. Loder*

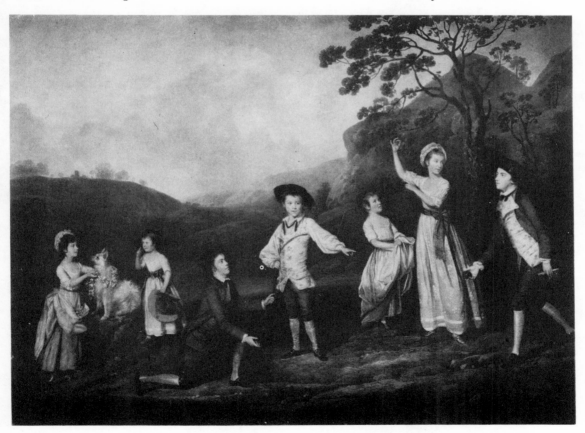

THE CHILDREN OF GEORGE BOND OF DITCHLING

Hugh Barron *Collection of The Hon. Frederick Wallop*

PLATE LXXIII

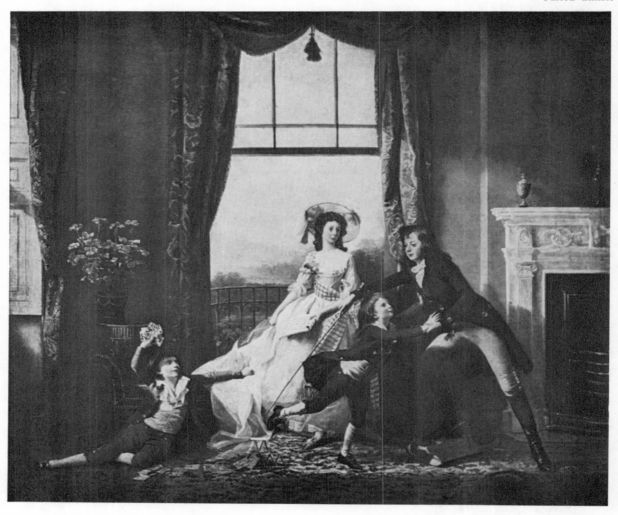

THE SITWELL FAMILY

John Singleton Copley

Collection of Captain Osbert Sitwell

PLATE LXXIV

Collection of Ronald Tree, Esq.

A FAMILY GROUP

Francis Wheatley

PLATE LXXV

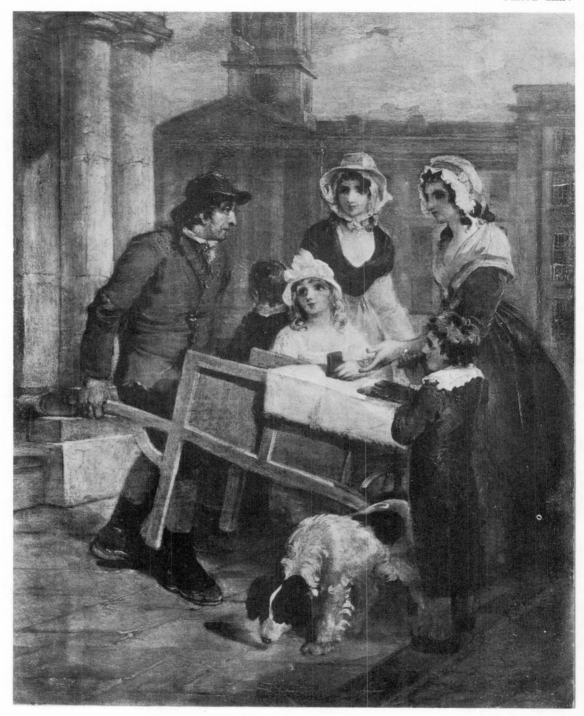

GINGERBREAD

Francis Wheatley *Collection of Sir Alfred Beit, Bart.*

PLATE LXXVI

A PEDLAR AT A COTTAGE DOOR

Collection of The Lord Camrose

Francis Wheatley

PLATE LXXVII

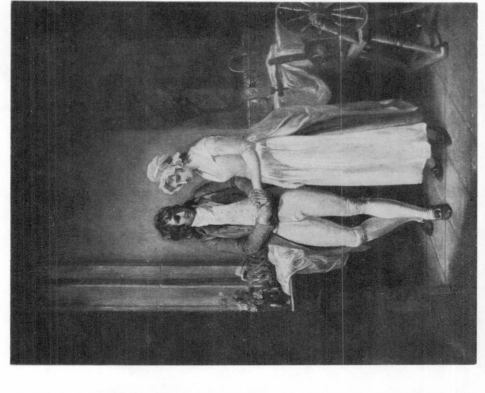

COURTSHIP

Collection of The Viscount Bearsted

Francis Wheatley

MAIDENHOOD

Collection of The Viscount Bearsted

Francis Wheatley

PLATE LXXVIII

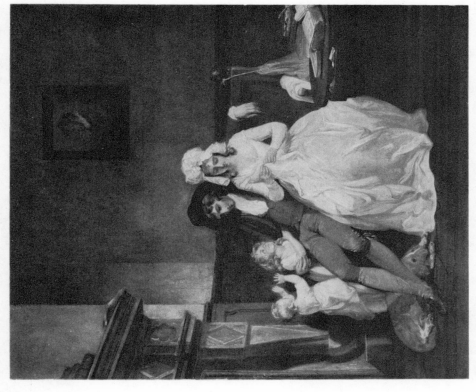

MARRIED LIFE *Collection of The Viscount Bearsted*

Francis Wheatley

Francis Wheatley *Collection of The Viscount Bearsted* MARRIAGE

PLATE LXXIX

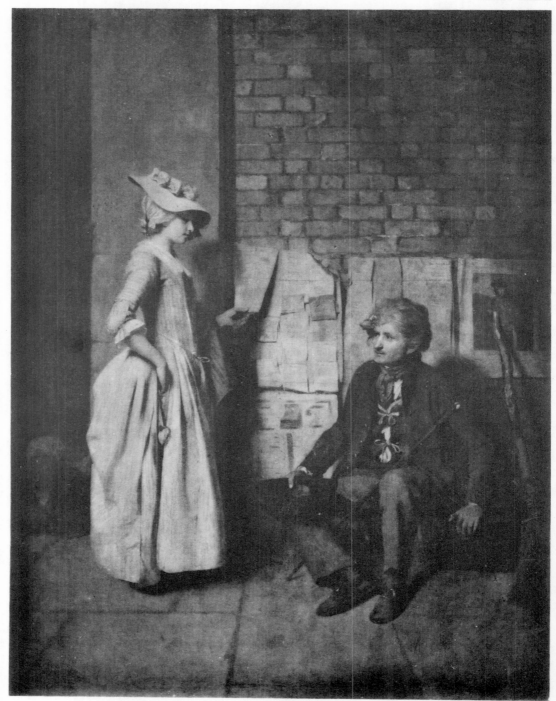

A YOUNG GIRL BUYING A LOVE SONG

Henry Walton

Collection of The Lord Mildmay

PLATE LXXX

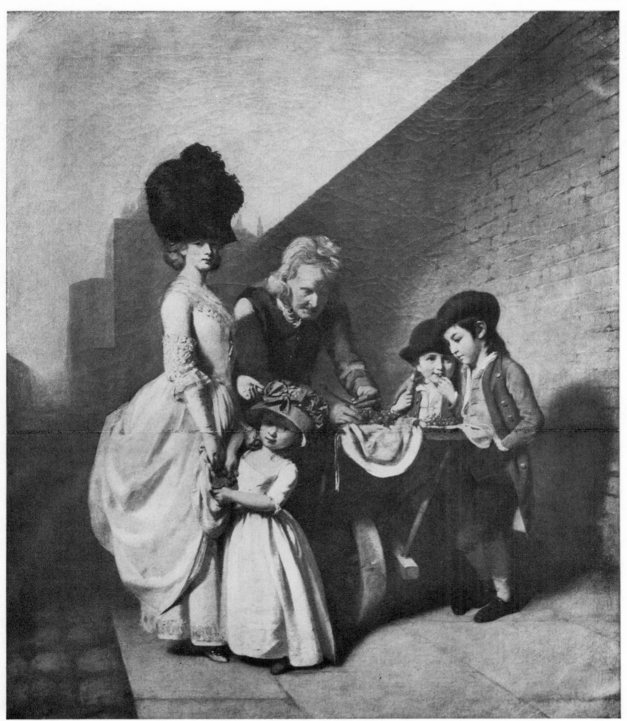

THE CHERRY SELLER

Henry Walton *Collection of Captain Osbert Sitwell*

PLATE LXXXI

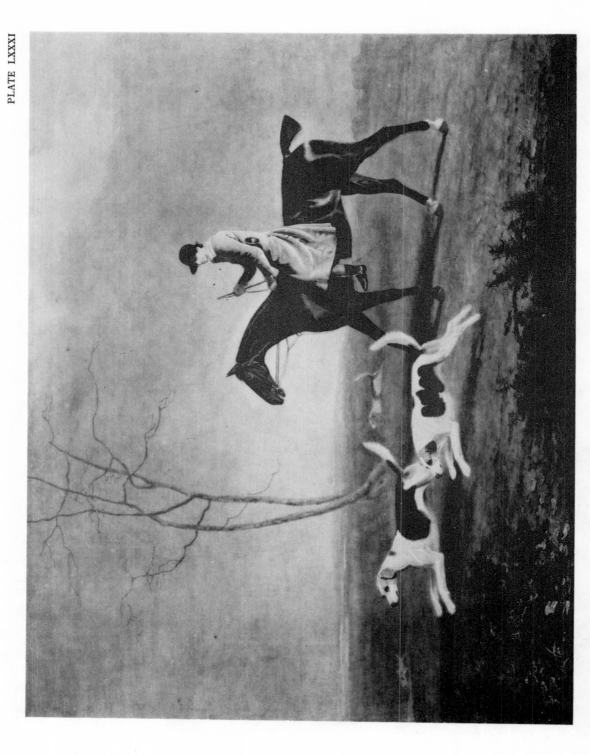

THOMAS OLDAKER ON HIS BROWN MARE "PICKLE"

Benjamin Marshall

Collection of The Lord Woolavington

PLATE LXXXII

Benjamin Marshall

MR. POWLETT AND HIS HOUNDS

Collection of the Lord Woolavington

PLATE LXXXIII

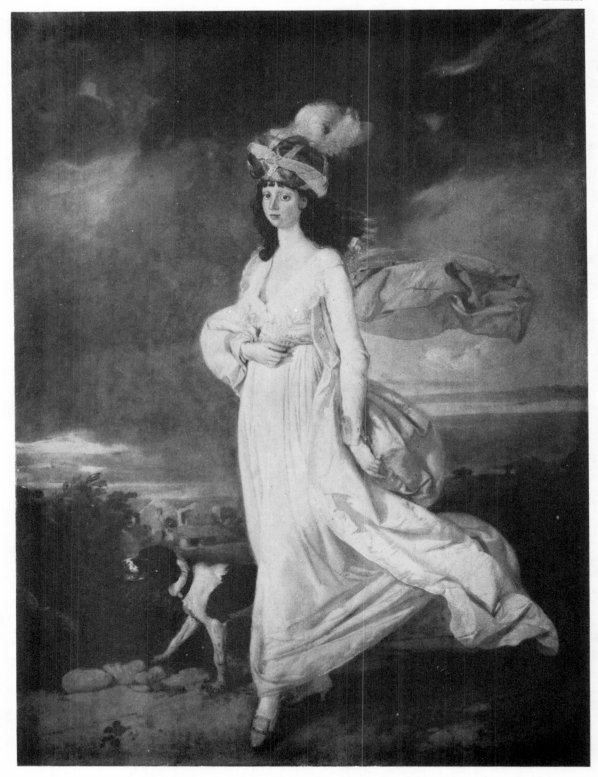

A YOUNG LADY WALKING IN A LANDSCAPE WITH A DOG

Benjamin Marshall *Collection of F. C. Graham Menzies, Esq.*

PLATE LXXXIV

HOLLAND HOUSE LIBRARY

Charles Robert Leslie

PLATE LXXXV

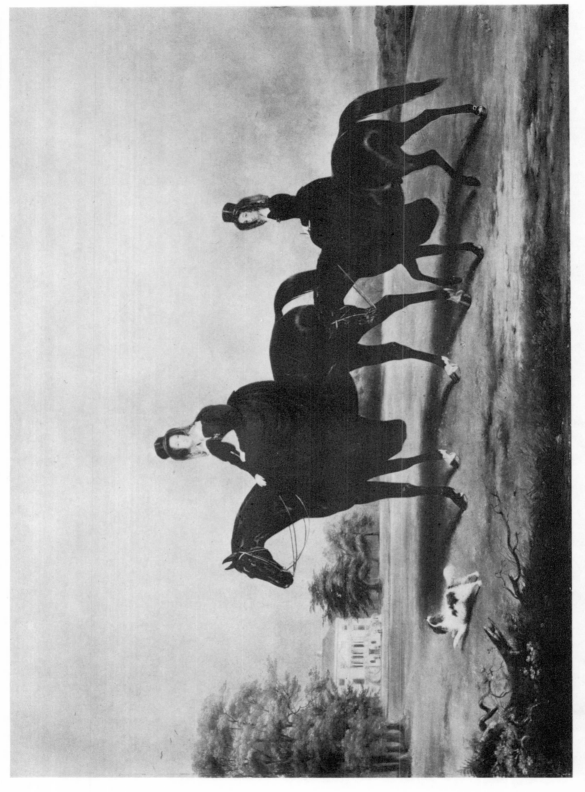

THE DUCHESS OF KENT AND HER DAUGHTER, AFTERWARDS QUEEN VICTORIA

Collection of Mrs. F. C. Graham Menzies

Henry and William Barraud

PLATE LXXXVI

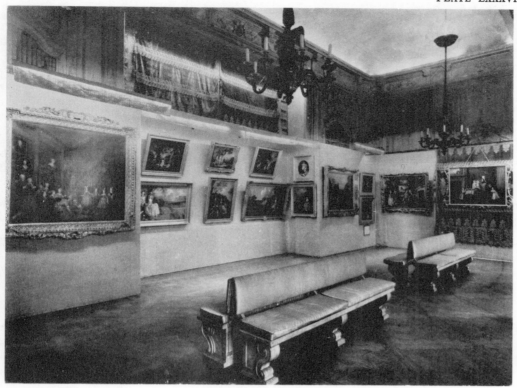

INTERIOR OF EXHIBITION
DRAWING ROOM

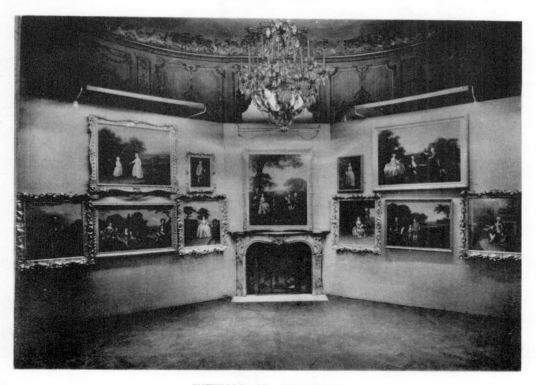

INTERIOR OF EXHIBITION
OVAL DRAWING ROOM

PLATE LXXXVII

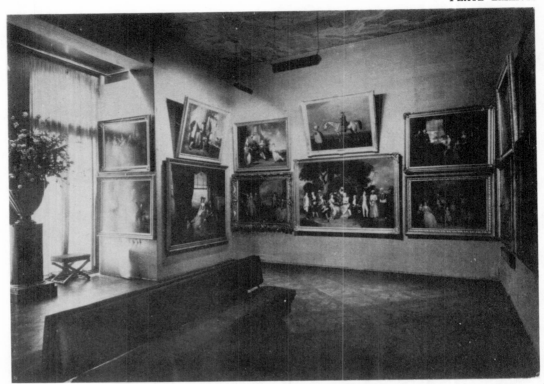

INTERIOR OF EXHIBITION
BALL ROOM

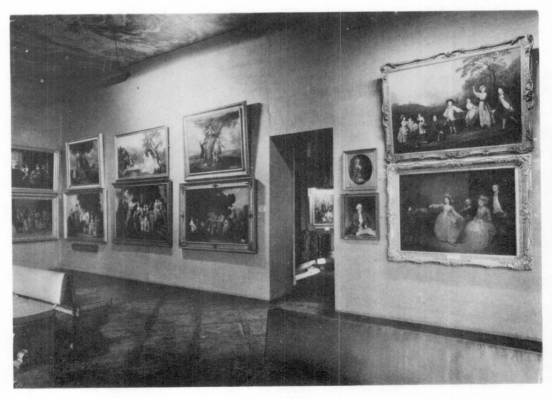

INTERIOR OF EXHIBITION
BALL ROOM

INDEX

Printed in U.S.A. by
NOBLE OFFSET PRINTERS, INC.
New York, N.Y. 10003